ARTIST'S
LIBRARY
SERIES

P9-BYM-769

Watercolor Painting Step by Step

By Barbara Fudurich, Marilyn Grame,
Geri Medway, and Lori Simons

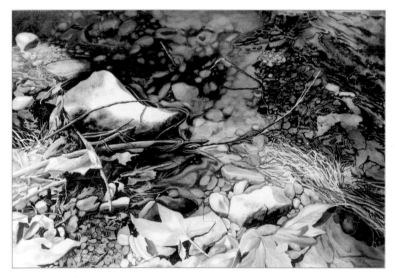

Beside Still Waters by Geri Medway

Contents

Quarto is the authority on a wide range of topics.
Quarto educates, entertains, and enriches the lives of our readers—
enthusiasts and lovers of hands-on living.
www.quartoknows.com

© 2002, 2013 Quarto Publishing Group USA Inc.
Published by Walter Foster Publishing,
a division of Quarto Publishing Group USA Inc.

Artwork on pages 3, 14, 52–63 © 2002 Barbara Fudurich.
Artwork on pages 14, 28–39 © 2002 Marilyn Grame. Artwork on pages 1, 15, 40–51
© 2002 Geri Medway. Artwork on pages 15, 16–27, 64 © 2002 Lori Simons.
All rights reserved. Walter Foster is a registered trademark.

6 Orchard Road, Suite 100
Lake Forest, CA 92630
quartoknows.com
Visit our blogs @quartoknows.com

Printed in China
5 7 9 10 8 6

Introduction

Watercolor is a fascinating and dynamic medium that lends itself to painting spontaneously. Because you can take so many different approaches to painting in watercolor, you can achieve a wide variety of rich, expressive results. For example, depending on how much you dilute your pigments, you can paint with thick, opaque applications or with thin, translucent washes. You can build up rich, intense blends by layering your colors, and you can create a range of special effects with simple materials, such as table salt, sponges, and toothbrushes. And because watercolor has a tendency to run and bleed in unexpected ways, you will often be pleasantly surprised by the accidental effects that result.

This book showcases the work of four accomplished watercolorists, each with a unique perspective regarding subjects, tools, and techniques. Individually they'll take you step by step through paintings as diverse as landscapes, still lifes, animal portraits, and flowers. And along the way, you'll learn the basics of watercolor painting as well as special tips and tricks from each artist. With each imaginative lesson, you'll enjoy discovering the information and inspiration you need to choose your own subjects, develop your own style, and paint your own masterpieces in watercolor!

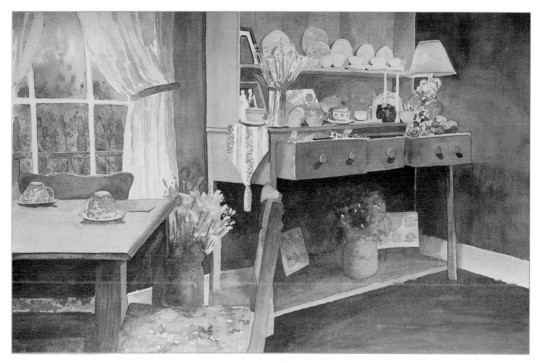

Respite by Barbara Fudurich

3

Tools & Materials

You'll find a remarkable variety of paints, brushes, and other painting materials at your local art supply store. And although it's tempting to buy everything you see, you really need only a few basic supplies to get started in watercolor. Just remember to always buy the best quality materials you can afford. Higher-quality products are easier to work with, they last longer, and they provide better results than their less-expensive counterparts do; you can add more tools later as your budget allows.

Paints

Watercolors are available in tubes, cakes, and pans. Tube paints are popular because they're easy to use and they last a long time; cakes and pans are small, light, and convenient to transport. Whichever type you choose, buy the artist-grade paints; they're made with better pigments and have fewer additives, so the colors are more vibrant and intense.

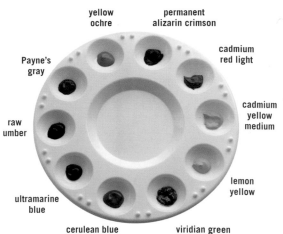

yellow ochre · permanent alizarin crimson · Payne's gray · cadmium red light · cadmium yellow medium · raw umber · lemon yellow · ultramarine blue · cerulean blue · viridian green

Basic Palette Each artist develops his or her own favorite palette of colors, and you will too as you practice and develop. The colors shown above make a good beginner's palette that will get you started.

Paint Choices Pan and cake watercolors are semi-dry blocks of color, often sold in sets like the one above. Tube colors are moist, and the tubes allow you to squeeze out as much or as little paint as you need.

Limited Palette

You don't need to buy every color that's manufactured; you can mix nearly any color you want from just a few. Just be sure to purchase at least one warm and one cool version of each of the primary colors (red, yellow, and blue), as shown in the basic palette (above, right). You can always add other colors later as your skills improve.

Expanding Your Color Palette

For the lessons in this book, you'll need to add the colors listed below to your basic palette. (Refer to each project for a complete listing of colors needed.)

- cadmium orange
- permanent rose
- burnt sienna
- raw sienna
- phthalocyanine ("phthalo") blue
- cobalt blue
- cobalt violet
- sap green
- burnt umber
- Chinese white or white gouache

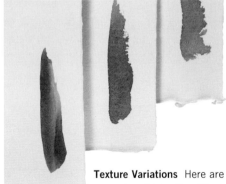

Texture Variations Here are examples of how the different papers take the paint (from left): hot-pressed, cold-pressed, and rough paper.

Paintbrushes

You can purchase either natural-hair or synthetic watercolor brushes; both come in a variety of styles and sizes (designated by a number, such as No. 2, or in fractions of inches). Again, buy the best you can afford, and experiment with different types and sizes to find the brushes you like the best. The five brushes shown at right make a good starter set, which you can add to later according to your own preferences. Choose brushes that quickly bounce back into shape after each stroke (referred to as *spring*), and make sure your rounds have a good point.

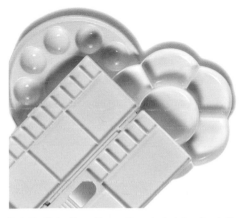

Palette Selection No matter what style of palette you choose, try to find one with a large, flat area for mixing and creating washes and one with plenty of wells for holding all your colors.

Supports

The surface you paint on is called the *support*. Supports can be anything from fabric to wood, but most watercolorists use various types of paper. *Hot-pressed* paper has a smooth texture, and *cold-pressed* paper has a medium texture. Watercolor paper also comes in different weights, designated in pounds. The higher the number, the heavier the paper. The 140-lb. paper is popular and is suitable for beginners, but a 260-lb. or 300-lb. paper won't warp under multiple layers of wet paint.

Flat This flexible brush is good for laying in washes or blocking in large areas of color.

Flat

Liner or Rigger These brushes are best for intricate lines and very fine details.

Liner or rigger

Small Round The fine points of these brushes make them an ideal choice for painting small details.

Small round

Medium Round This is a good all-around brush that can produce thick or thin lines, depending on the amount of pressure you apply.

Medium round

Large Round This brush can hold a lot of water or paint and is ideal for applying medium to large areas of color.

Large round

Palettes

Palettes come in different materials (plastic, glass, china, or metal) and in varied shapes (round, oval, rectangular, and square). Plastic is lightweight and less expensive than porcelain, but all clean up easily with soap and water. Some plastic palettes even have lids so you can save your colors between painting sessions. When you paint, consider placing the colors in the same order on your palette each time. That way you're less likely to pick up the wrong one by mistake!

Workspace

Your work station can be an elaborate structure or just a corner in a room, but two elements are absolutely essential: comfort and good lighting—natural light is best. If possible, set up your studio in a place where you'll have few distractions, and include a supportive chair. When you're comfortable, you'll be able to paint for longer stretches of time, and you'll find the overall experience more pleasant.

Work Station When you set up your workspace, keep all your materials within easy reach, and make sure you have adequate artificial light if you work at night.

Drawing Board or Easel

When selecting a drawing board or easel, look for functionality and versatility. Choose a smooth board that can be tilted or easily propped up. Many boards have carrying handles, and some come with clips for holding your paper in place. If you prefer to use an easel, make sure you can adjust the height. You may want to consider a tabletop version so you can sit down to work.

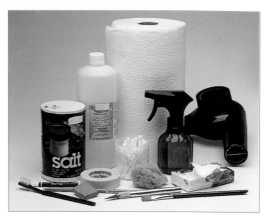

Extras Although you may not use these additional tools on every painting, it's a good idea to have them on hand.

Supply Checklist

Here's a list of the basic supplies you'll need to get started painting with watercolor. (For specifics, refer to the suggested brushes and colors on pages 4–5.)

- Five paintbrushes
- Ten watercolor paints
- Watercolor paper
- Mixing palette
- Drawing board or easel
- Water containers: at least two—one for rinsing your brushes and one for holding clean water

Other Necessities

Besides the essentials, you'll find these items helpful: sketching materials; a white crayon, sponge, toothbrush, salt, alcohol, cotton swabs, and tissues for special effects; a utility knife for scraping; masking tape for straight edges; a hair dryer for speeding up drying time; and a spray bottle to keep your paints (and your paper) moist. A brush with an angled handle can also be useful for scraping off paint and quickly mending mistakes.

Preparing Paper

Light- or medium weight papers can warp when you apply wet paint, but they will stay flat if they are stretched first. There are two compelling reasons for stretching paper: it can save you money because lightweight paper is considerably less expensive than heavy paper, and it's more pleasant to work on because it eliminates the ridges caused by buckling. Stretching paper isn't difficult, but you will need to do it well in advance of painting; you need to soak the paper in water, and it will take at least two hours to dry completely.

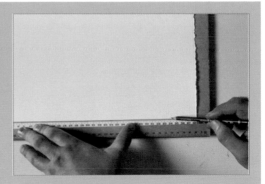

Step 1 You'll need a ruler, pencil, scissors, gummed or masking tape, a sponge, and a flat board or other work surface. First use a ruler to draw light pencil lines as a guide for the tape. Draw the lines all around the paper, about half an inch away from the edges.

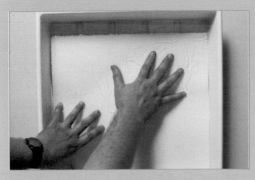

Step 2 Fill a sink, tub, or large tray with clean water, and then immerse the paper briefly. Turn it over once to make sure both sides are evenly and thoroughly wet.

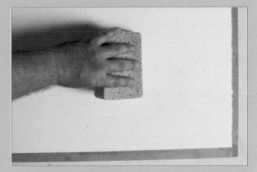

Step 3 Place the paper on your board or work surface, and then smooth over it with a damp sponge to remove any creases or air bubbles.

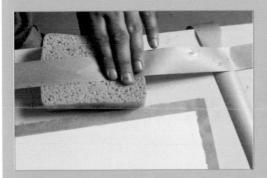

Step 4 Cut four pieces of tape a little longer than the lengths of the four sides of the paper. If you're using gummed tape, dampen the gummed side slightly by pulling it over the wet sponge. Don't wet it too much, or it may stretch and tear.

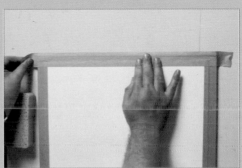

Step 5 Place the strips of tape along the four edges and press them in place, smoothing them with your hand as you go. Trim away the excess tape with scissors, and then stand the board upright until the paper is completely dry.

Color Theory & Mixing

Color is one of the most important aspects of a painting, and not only in terms of accurately representing your subject. The choices you make also affect the viewer's emotional reaction. We associate red with passion and anger, blue with melancholy and peacefulness, and yellow with joy and warmth. So your choice of colors will determine whether your painting is seen as vibrant and dramatic, cool and refreshing, or warm and comfortable. A basic knowledge of how colors relate is essential to help you convey mood and elicit an emotional response from—or make a connection with—the viewer.

Color Basics

Some basic knowledge about color will go a long way when it comes to mixing your own paints. The *primary colors* (red, yellow, and blue) are the three basic colors that can't be created by mixing other colors. All other colors are derived from these three. Each combination of two primaries results in a *secondary color* (purple, green, or orange), and a combination of a primary color and a secondary color results in a *tertiary color* (such as red-orange or red-purple). On the color wheel, at right, the colors across from each other are *complementary* colors, and groups of adjacent colors are *analogous* colors.

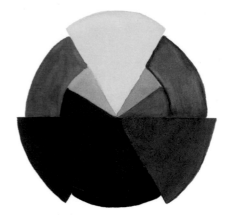

Color Wheel A color wheel is a handy visual reference that demonstrates color relationships. Knowing the basics of how colors relate to and interact with one another will help you create different moods—and develop interest and unity—in your watercolor paintings.

Color Psychology

Colors are often classified in terms of "temperature." The "warm" colors are red, orange, and yellow, and the "cool" colors are green, blue, and purple. But there are variations in temperature within every family of color, or *hue,* as well. A red that contains more yellow, such as cadmium red, is warmer than a red that contains more blue, such as alizarin crimson. The "temperature" of the colors you use can express a mood, a season, or the time of day. For example, we associate warm colors with energy and excitement, summer, and afternoon or sunsets, while we associate cool colors with morning, evening, and winter—times of quietude.

Vivid Secondary Colors For vibrant secondary colors, mix two primaries that have the same "temperature" (e.g., two cools or two warms).

Muted Secondary Colors To create muted, subdued secondaries, mix two primaries of opposite "temperatures" (e.g., a warm with a cool).

Mixing Neutrals

Complementary colors (any two colors opposite each other on the color wheel) provide dramatic contrasts and high vitality. But when complements (for example, red and green) are mixed together, they create neutral colors. And when the three primaries are mixed, a striking range of neutral grays and browns results, as shown in the examples below. Learning to mix neutrals is important because most colors you'll see in nature are more subtle and muted than the pure and vibrant color that comes straight out of the tube.

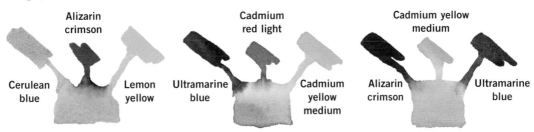

Alizarin crimson · Cerulean blue · Lemon yellow

Cadmium red light · Ultramarine blue · Cadmium yellow medium

Cadmium yellow medium · Alizarin crimson · Ultramarine blue

Mixing the Three Primaries When a primary color stands alone or is mixed with one other primary color, the result is a bright, vivid color. But when you include all three primaries in your mix, varying the quantities of each, you'll find that you can create a wide range of dynamic neutral colors.

Values in Watercolor

Value is the relative lightness or darkness of a color (or of black), and it is variations in value that create the illusion of depth and form in a painting. With opaque media, like oil paint, you lighten the value of your colors by adding white, and you generally begin with your darks and build up the lights. With watercolor, you lighten the values by adding more water (the lightest value being white of the paper), and you usually start with the lightest values and build up your darks.

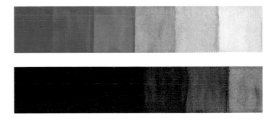

Value Scale To get a feel for the different values you can create, practice making value scales like the ones above. (Notice that these scales don't show all the light values possible.) Apply pure pigment at the left, and gradually add more water for successively lighter values.

Using Frisket

Using frisket is a way of saving the white of your paper. *Liquid frisket, or masking fluid,* is the type most commonly used by watercolorists. To apply, dampen an old brush and stroke it over a bar of soap (the soap will keep the bristles from absorbing too much fluid); then paint the frisket over the areas you want to remain white. Wash the brush and let the frisket dry completely. To remove the dry mask, rub it gently with your finger or with a rubber eraser.

Frisket Types Liquid frisket, or masking fluid, is a latex-based substance that is either white or slightly colored. (Colored mask is easier to see on white paper.) Paper frisket is a clear adhesive that you cut with scissors or a utility knife and adhere to the painting surface.

Layering or Glazing

Because watercolor has a transparent quality that allows the white of the paper to shine through the paint, it can be difficult to achieve darker values with one coat of watercolor alone. The best way to establish your darks is by building them up in layers, or *glazes*, of thin, diluted color. Glazing also allows you to change a color or create a mix on paper instead of on your palette. To glaze, apply a layer of paint and allow it to dry; then paint another layer of color over the first. Instead of physically mixing on the paper, the eye mixes the color visually. Experiment with various combinations of colors like the ones shown below—you'll achieve a unique result with each.

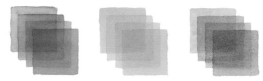

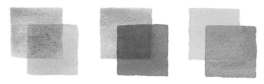

Layering to Darken Color To darken a color, layer glazes of successively darker values (more pigment and less water). Always make sure the first color is completely dry before glazing the next, and try not to overwork the top colors—you don't want to disturb the colors below.

Layering to Mix Colors In watercolor, when you paint a new color over an existing one, the color underneath still shows through. (With oil or acrylic, the underlying color would be completely masked.) Layering red over blue, for example, results in a purple blend.

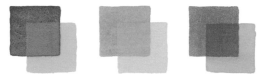

Layering with More Opaque Color Some watercolors are more opaque than others. As shown above, strong values of cerulean blue, lemon yellow, and yellow ochre lighten the value of the darker color beneath; ultramarine blue and Payne's gray darken it.

Layering Light over Dark If you paint a lighter color over a darker one, the lighter color won't significantly change the underlying color's value. The exception to this rule occurs when you paint over the darker color with one of the more opaque colors.

Using Granulation

Some colors you mix on your palette or paper will dry with a mottled, speckled look. This effect is called "granulation," and it occurs when pigments separate from the water. Coarser pigments are used to create certain watercolor paints, and they are more likely to settle into the depressions of your paper or support. Some watercolorists use the grainy effect that results either to create the suggestion of texture or simply to add a little more interest to an otherwise ordinary wash.

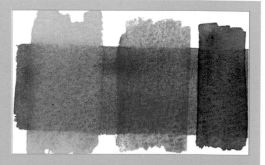

Granulation Effect This is an example of granulated effect (the technical term is precipitation) you get by layering watercolors. The effect is more apparent with some colors than it is with others. Here yellow ochre, cerulean blue, and alizarin crimson have been layered over ultramarine blue.

Experimenting with Color Mixes

It's possible to create a full range of exciting color possibilities from just a small collection of colors. A limited palette is uncomplicated, yet it can produce a wide variety of lively colors, as demonstrated in the chart below. Keeping mixes simple keeps them fresher and more intense, without forfeiting the expressiveness of the painting.

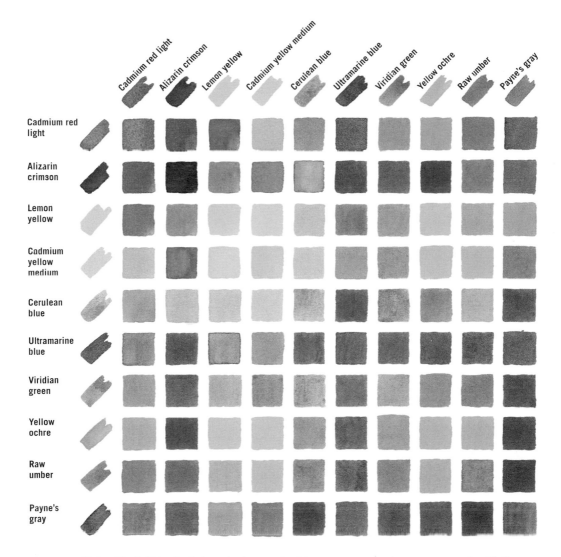

Mixing Chart This chart shows just a sample of how many more colors you can create with the basic palette presented on page 4. Each of the colors on the chart is a two-color mix. You can create even more variety by mixing three colors together, but most watercolorists agree that any number beyond that usually just produces a muddy mix. All the colors here are equal 50/50 mixes, but changing the proportion of one color to the next can dramatically affect the results. Charts like this are a useful reference, especially when you create them using your own palette and combinations.

Watercolor Techniques

An important aspect of watercolor painting is controlling moisture. The strength of a color, the fluidity of the paint, and the texture of a brushstroke are all determined by the amount of water used. Although washes are the most basic method of applying watercolor, there are also a number of specialized techniques that can create dynamic effects, as shown in the examples here. Every technique produces a unique result, so be sure to familiarize yourself with each!

Flat Wash

A *flat wash* is a simple way to cover a large area with solid color. It can play the role of a flat backdrop to more dramatic visual elements or serve as an initial layer of color, or *underpainting*. Washes can be laid in on wet or dry paper, and a combination of the two can also produce expressive results. For a flat wash, load your brush with color before each stroke to maintain the same depth of color overall.

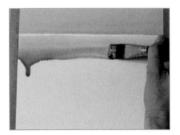

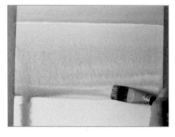

Step One Begin by tilting your support. Load your brush with color, and apply a horizontal stroke all the way across the top of the paper.

Step Two Load your brush again and make another overlapping horizontal stroke, picking up the drips and runs from the stroke above.

Step Three Continue loading your brush and overlapping your strokes, always working in the same direction. (Any streaks will even out as it dries.)

Graded Wash

Graded washes are the perfect method for painting realistic water and skies. Graded washes are laid in the same way as flat washes are, but more water is added to the pigment for each successive stroke of paint, so the color gradually fades as you work your way down. You can also create a *variegated wash* by adding different colors with each stroke.

Step One Tilt your board at an angle, and begin with a horizontal band of pure (undiluted) color.

Step Two Before applying each new band of color, add more water to your brush so each is lighter in value.

Step Three Continue adding water and overlapping strokes until you achieve the lightest value desired.

Special Techniques and Effects

Scraping Use a pointed tool, such as a brush handle, to scrape away wet paint, revealing lighter values beneath.

Using Salt Sprinkle salt over wet paint; then brush it away when dry to create a dappled texture.

Spattering Run your thumb against a toothbrush loaded with paint, or tap a loaded flat brush against your finger.

Using Alcohol Drop rubbing alcohol onto a wet wash. The colors will "push" around into interesting blends.

Saving the White Use frisket to "save" whites. Frisket resists the paint and preserves the white of the paper.

Using Wax Resists Apply wax between layers of color. Wax repels the paint and protects the first layer of color.

Wet-into-Wet Paint wet color onto a wet support to produce soft edges and smooth blends.

Wet-on-Dry Paint wet color onto a dry surface for crisper edges and more control over the spread of color.

Drybrush Remove excess moisture from the brush and stroke color over dry paper to create rough textures.

Sponge Apply paint with a sponge for mottled, sandlike textures; the finer the sponge, the finer the texture.

Back Runs Apply two colors wet-into-wet, and allow them to run and blend for soft shapes and reflections.

Correcting Mistakes Take a wet brush and gently rub it against the paper to scrub out unwanted color.

About the Artists

Barbara Fudurich

Barbara learned the art of watercolor painting through a number of workshops with widely known artists. Her favorite subject matter is the relationship between humans and nature, and she loves to paint on location. She has traveled throughout the southwestern United States, Hawaii, and Europe in her quest for exciting new subjects and venues.

Barbara's award-winning paintings have been juried into a number of art shows, including the Western Federation of Watercolor Societies, Echoes and Visions, and the Orange County Artists Showcase. Barbara is a member of both the San Diego Watercolor Society and Watercolor West, and her paintings are a part of private collections in the United States, Canada, and Europe.

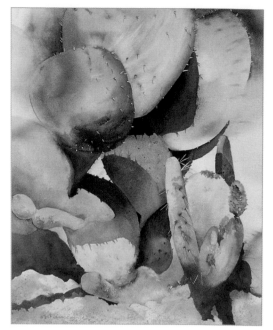

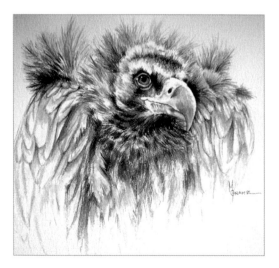

Marilyn Grame

Marilyn has always been artistically inclined. An art instructor for 30 years, she has refined her natural talent by studying with several west coast professionals and through continuing experimentation. Marilyn is an Arts and Letters member of the National League of American Pen Women and a member of the Foothills Art Association in La Mesa, California and the Pastel Society in San Diego. She is also a demonstrator, a juror, and a designer of enamel jewelry.

Marilyn's special affection for animals is showcased in her realistic renderings of wildlife. Her paintings are in private collections throughout the United States and abroad.

Geri Medway

Geri attended the American Academy of
Art in Chicago, Illinois, majoring in graphic
design. She has continued her training
by attending a number of workshops in
California, Washington, and Italy. Geri is
a signature member of the National Water-
color Society, a juried associate member of
Watercolor West, and a member of a
cooperative, artist-owned gallery in Laguna
Beach, California.

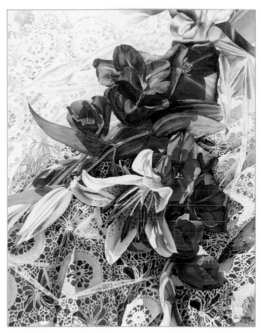

Geri is an award-winning watercolorist and
regularly exhibits in juried art festivals
in Southern California. Her work is included
in galleries throughout California as well as in
private and corporate art collections in the
United States and Europe. Her work has been
published in *Art of the American West,* by Sunrise Greeting Cards, and by Verkerke Reproduckties
in the Netherlands.

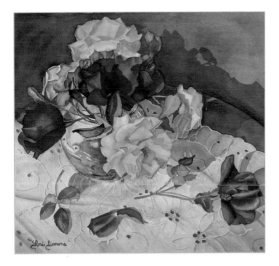

Lori Simons

Lori earned her bachelor's degree in fine arts
from the University of Arizona. Although
she has had formal art training, she credits
much of her watercolor expertise to studying
under artist Sondra Freckelton. Lori now
teaches her own drawing and painting
workshops out of her studio in Manchester,
New Hampshire.

Lori's paintings have been accepted into
several nationally juried exhibitions and
featured in *American Artist* magazine. As an
arts writer, she has published more than 30
articles in a variety of national and international art magazines, and her paintings are
represented in several New England galleries.

Selecting a Subject
with Lori Simons

Deciding what to paint can be challenging because there are so many wonderful subjects to choose from. But selecting a subject is also an expression of your personal style, taste, and creativity. Choose a subject you care about, whether because it evokes an emotional response, has special meaning for you, or is simply pleasing to the eye. For this project, watercolorist Lori Simons describes how she captured the unique play of light and shadow across the simple architecture of a charming white house, eloquently portraying a crisp autumn afternoon in New England. When you choose your own subjects to paint, remember that the more strongly you feel about your subject, the more your emotions will show through in your work, and the more successful your paintings will be.

Color Palette

burnt umber, cadmium red medium*, cadmium yellow medium, cerulean blue, cobalt blue, lemon yellow, permanent alizarin crimson, Prussian blue*, raw sienna, sap green, ultramarine blue, viridian green

* colors marked with an asterisk are not listed in the basic palette on page 4.

Step One I work out my composition on graphite paper and then transfer it to my support by placing the graphite side down on the paper and tracing over the lines. Next I apply liquid frisket for the areas of sky peeking through the leaves. Once dry, I lay in my base colors, beginning with a light, flat wash of raw sienna at the top of the house and adding alizarin crimson about halfway down. For the bushes, I paint around the fence posts, using a small round brush and sap green; then I use sap green mixed with lemon yellow for the lawn and

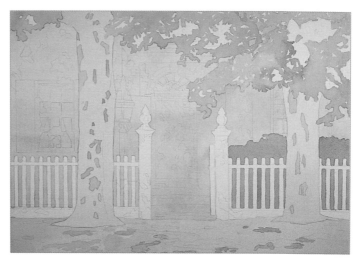

pure cadmium yellow medium for the fallen leaves. For the tree foliage, I use various mixes of sap green, lemon yellow, and cadmium yellow medium. I use cobalt blue for the tree trunks. When dry, I glaze over the highlights with raw sienna.

House Base	Lawn	Tree Foliage
Raw sienna and alizarin crimson	Sap green and lemon yellow	Sap green, lemon yellow, and cadmium yellow medium

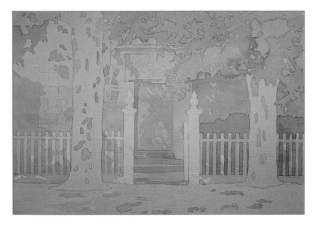

Step Two When the first layer is dry, I rub off the frisket. Then I paint the areas of sky that are visible through the leaves with a transparent mix of ultramarine blue and burnt umber. I lay in the pattern of shadows on the house and fence using the same mixture. I also add another layer of sap green and lemon yellow to the grass.

Sky, House, and Fence Shadows

Ultramarine blue
and burnt umber

Step Three Next I start placing the medium values on the house, begin-ning with a mix of ultramarine blue and alizarin crimson for the shutters, the door knocker, and the shadows on the ground. I also paint the dark areas behind the windowpanes, carefully working around the lattice, lamp, and curtains. I lay a second glaze of ultramarine blue and alizarin crimson over the windowpanes, this time leaving some gaps in the color to indicate reflections. When the shutters are dry, I use my small round brush to add the detail lines with dark ultramarine blue. Then I paint the lamppost behind the tree with the ultramarine blue and burnt umber mix.

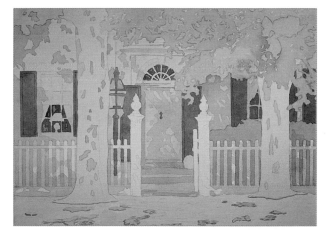

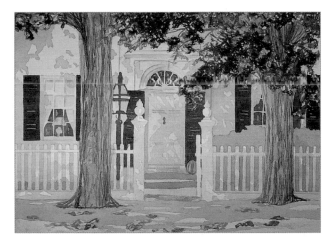

Step Four Working from light to dark and with quick, loose strokes, I paint the tree foliage (see the details on pages 18–19). Then I develop the tree trunks with irregular, vertical strokes of Prussian blue mixed with burnt umber. While still damp, I score vertical lines in the trunks with my brush handle, letting the paint flow into the indentations for added depth and texture. When dry, I glaze over the trunks with burnt umber, starting at the right and gradually lightening the values toward the sunlit side. Then I deepen the color of the shutters and windowpanes with a glaze of ultramarine blue mixed with burnt umber.

17

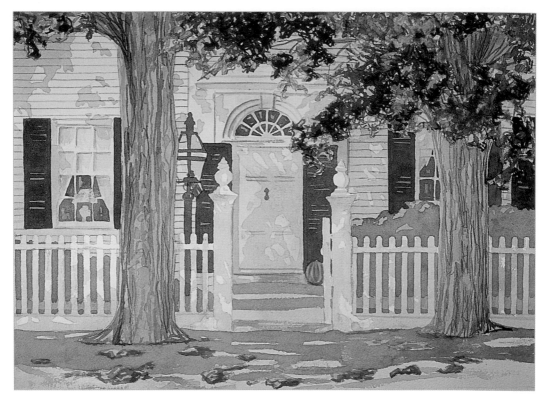

Step Five Next I continue building up my values. I glaze a layer of raw sienna over the lightest areas of the fence and fence posts. I apply lemon yellow to the pumpkin on the porch and then add a glaze of cadmium red medium. I also use cadmium red medium to paint stripes on the flag behind the lamppost, and I add a second hedge on the left with a wash of sap green. When the paint is dry, I glaze over the hedges and the shadows on the lawn with a mix of viridian green and burnt umber; then I fill in the shadows on the fence posts with cerulean blue. I switch to a script liner brush to paint the horizontal lines for the siding of the house, using raw sienna in the sunlit areas and my ultramarine blue and burnt umber mix in the shadows.

Lawn Shadows

Viridian green and burnt umber

Painting the Leaves

Step One With my small round brush and loose strokes, I apply the first glazes over my base color with varying values of sap green mixed with cadmium yellow medium.

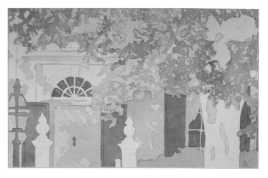

Step Two When this first layer is dry, I add darker values of the same sap green and yellow mix. I'm just laying in masses of values, not trying to render each individual leaf.

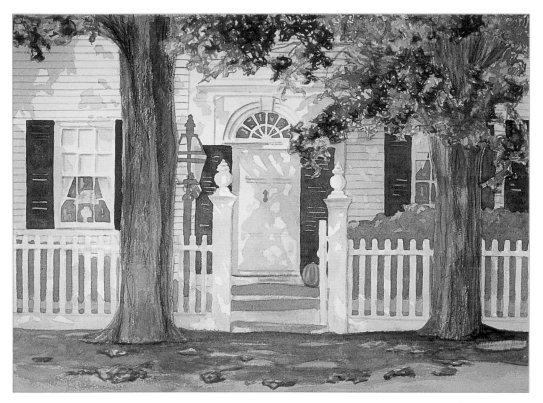

Step Six I finish by adding all the darkest values. To push the right side of the house back into the shadows, I add a glaze of ultramarine blue mixed with burnt umber. I also use this color to darken the right portion of the sky behind the leaves. I glaze the shutters with a mix of Prussian blue and burnt umber, painting around the highlights. Next I glaze the shadows on the front door with ultramarine blue mixed with just a touch of burnt umber. I deepen the shadows on the grass with a wash of viridian green mixed with burnt umber, and I paint a mix of sap green and cadmium yellow medium over the lighter areas. Finally I add a bit more texture to the tree trunks using burnt umber and a drybrush technique (see page 13).

Shutter Glaze

Prussian blue and burnt umber

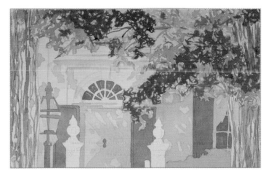

Step Three I wait for the paint to dry again, and then I add the red leaves with the same loose strokes and a mix of cadmium red medium and alizarin crimson.

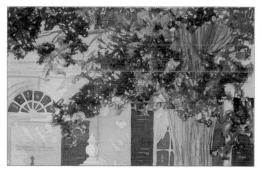

Step Four When the colors are dry, I apply a glaze of viridian green mixed with burnt umber to establish the darkest values of the foliage and create a sense of depth.

Developing Form
with Lori Simons

One of the most satisfying experiences for an artist is making an object appear three-dimensional on a flat surface. It's easy to see an object's shape and color—and once you've drawn its shape, rendering its form is simply a matter of manipulating the different values of color to give it depth and dimension. If you have trouble seeing the ranges of values in your subject, try squinting your eyes. You'll find that all the details become blurred and your subject is reduced to masses of values, with distinct shadows and highlights. In this still life, Lori Simons demonstrates how to use ranges of values and layers of glazes to develop form using the simple geometric shapes of the fruit as examples. Once you're comfortable depicting the forms of apples, grapes, and pears, you'll be ready to tackle any subject!

Color Palette

burnt umber, cadmium red medium*, cadmium yellow medium, cerulean blue, cobalt blue, lemon yellow, permanent alizarin crimson, Prussian blue*, raw sienna, sap green, ultramarine blue

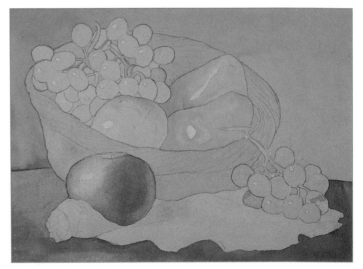

Apple Detail For my graded wash, I start with clear water where the lightest values are (on the left in the example above). First I gradually add sap green and then raw sienna, ending with cadmium yellow medium at the bottom right.

Step One After I sketch the basic shapes, I use a large round brush to wash in the background with raw sienna. Next I lay in my base colors. I paint the table with a mix of alizarin crimson, cadmium red medium, and raw sienna, and I paint the basket with cadmium yellow medium mixed with raw sienna. For each piece of fruit, I leave the highlights white, lifting out any pooled pigment near them with a clean, damp brush. I wash cadmium yellow medium over the lighter grapes, changing to cobalt blue for the grapes in shadow and to sap green for the stems. For the apples, I use a graded wash (see the detail at left) to begin establishing their forms, indicating the light, medium, and dark values. I begin the apple in the basket with sap green, gradually adding more and more cadmium yellow medium. Then I paint the foreground pear with a mix of cadmium yellow medium and raw sienna, switching to sap green mixed with raw sienna for the pear behind it. When dry, I lay a very light wash of raw sienna over the sea shell and the light-colored cloth.

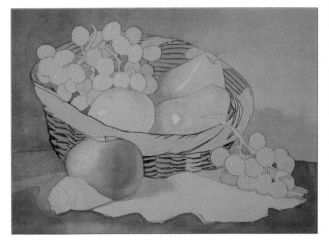

Step Two To create shadows on the table, on the underside of the basket, and in the background, I mix ultramarine blue with a touch of burnt umber. As I work toward the upper-right corner of the painting, I add more water to the wash and then use more pigment as I move down to the basket's cast shadow. I continue painting the shadows on the basket, on the cloth, on the pears, and in between the grapes. Then I use a liner brush with the same mix—but with less water—to paint the dark lines on the basket.

Step Three Next I begin developing the forms of the grapes with graded washes, starting with clear water around the highlights and adding alizarin crimson toward the outside edge. I use the same technique for the other fruit, painting the rear pear with a mixture of sap green and lemon yellow and the front pear with a mixture of sap green and raw sienna. I glaze over the entire basket with a mix of burnt umber, cadmium red medium, and cadmium yellow medium, thinning out the glaze near the lighter parts of the basket rim.

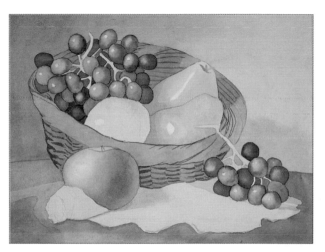

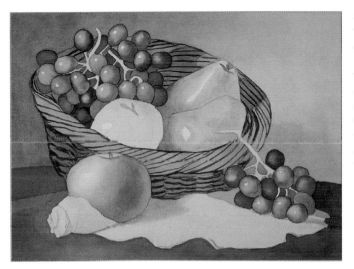

Step Four I continue building the forms by glazing the background with a mix of ultramarine blue and burnt umber. Then I use the same mix for another glaze over the shadow areas on the basket, the white cloth, and the pears. I also apply a glaze of alizarin crimson mixed with raw sienna over the table. These glazes add depth and richness to the colors, further defining their forms.

Glaze

Ultramarine blue
and burnt umber

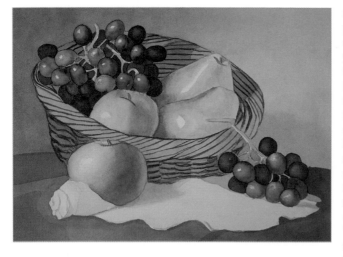

Step Five I use a liner brush to paint a thick mixture of burnt umber, cadmium red medium, and cadmium yellow medium over the lighter lines of the basket. Then I go over the darker lines with a mixture of Prussian blue and burnt umber. I use this same mix to darken the shadows on the pear, scrubbing in the color with a damp brush. Next I apply another glaze of sap green over the stems. I also paint some of the darker grapes, using alizarin crimson for the lighter values and gradually adding more and more ultramarine blue toward the shadows. Then I use the tip of my brush to drop a thick bead of cerulean blue on the highlights of some of the darker grapes.

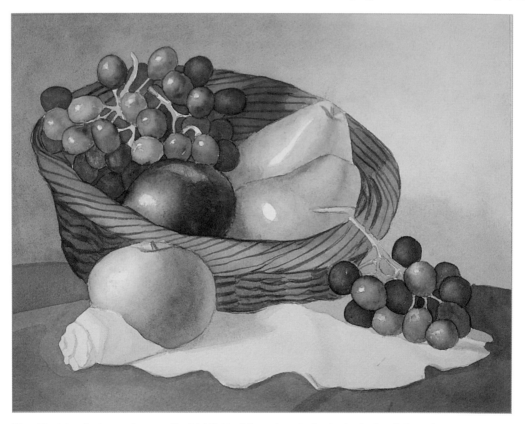

Step Six I brush clear water near the highlight of the red apple (in the basket) to lighten the color, adding ultramarine blue as I near the shadows to deepen those values. For the green apple, I work from the clear water at the highlight to sap green mixed with ultramarine blue in the shadows. On both apples, I soften any hard lines between the values with a damp brush. For the middle shadows of the pears, I first wet the areas of the lightest values with clear water. Then, with a very thick, dark mix of sap green, cadmium yellow medium, and raw sienna, I use the tip of my brush to apply color to the wet area, working down with horizontal strokes and following the form of the fruit.

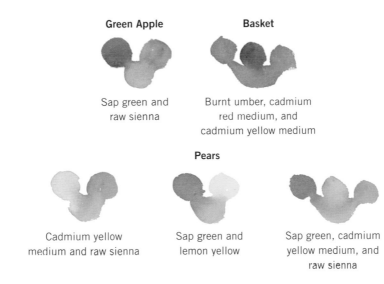

Green Apple

Sap green and
raw sienna

Basket

Burnt umber, cadmium
red medium, and
cadmium yellow medium

Pears

Cadmium yellow
medium and raw sienna

Sap green and
lemon yellow

Sap green, cadmium
yellow medium, and
raw sienna

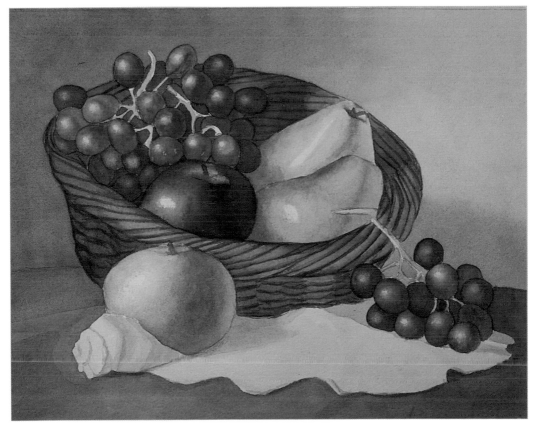

Step Seven To finish, I paint a final glaze over the entire basket, using a mixture of burnt umber, cadmium red medium, and cadmium yellow medium. I also complete the red apple, starting with clear water around the highlight and gradually adding cadmium red medium. Once again, I use a damp brush to soften the hard edges. I glaze lemon yellow over the rear pear, painting around the highlight. When this has dried completely, I glaze the front pear with raw sienna, again painting around the highlight. Finally I add a light, diluted wash of cerulean blue over all the highlights to soften the pure white.

Composing a Still Life

with Lori Simons

The wonderful thing about painting still lifes is that you have complete control over the arrangement. You can choose what objects to include, what lighting to use, and where to place each element to make a pleasing composition. As you arrange your objects, keep in mind that a good composition leads the viewer's eye into and around the painting, but always toward the center of interest, or *focal point*. Here Lori Simons has created a simple but dynamic composition by overlapping her objects and by placing her focal point—the pitcher of tulips—slightly off center. Notice that your eye is drawn in along a curving path from the pattern of the lace through the pearls and the teacup to the pitcher of flowers.

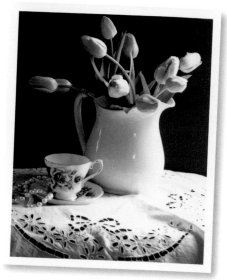

Color Palette

burnt umber, cadmium yellow medium, cobalt blue, permanent alizarin crimson, Prussian blue*, raw sienna, ultramarine blue, viridian green

Taking Artistic License I loved the simple elegance of the setup in this photo, but the color of the background was too strong for me. I exercised my artistic license by changing the warm background to cool, blue tones. This helped bring the focus back to where it should be—on the tulips and teacup.

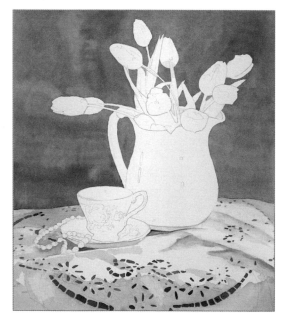

Background

Ultramarine blue
and alizarin crimson

Step One After transferring my sketch, I use a medium round brush to wash a light mix of ultramarine blue and alizarin crimson over the background. I hold the paper at an angle so my strokes blend together. I also rotate my paper as I paint so I can always stroke from left to right. Then I use a light wash of the same mix in the holes in the lace. When dry, I apply shadows on the lace with diluted ultramarine blue mixed with burnt umber.

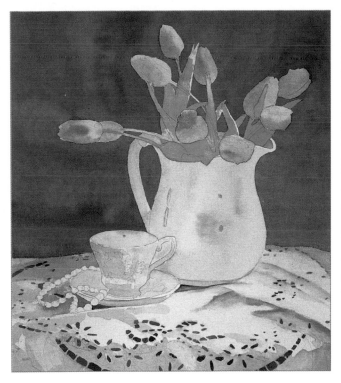

Step Two For the base color of the tulips, I paint graded washes of cadmium yellow medium, gradually adding more and more alizarin crimson until I have pure alizarin at the edges. (I turn the paper sideways for these washes, to let gravity help my strokes blend together.) Then I add a flat wash of sap green for the leaves. Next I apply liquid frisket to the highlighted areas of the pitcher, the teacup, and the pearls. When the frisket has dried, I turn my paper sideways again and paint the left side of the teacup and pitcher with a light wash of raw sienna. I add diluted cobalt blue, gradually adding more blue until I end with pure, light cobalt blue. Then—on the pitcher only—I continue my graded wash by adding very light (almost transparent) alizarin crimson.

Teacup and Saucer

Cobalt blue and burnt umber

Leaves

Prussian blue, cad. yellow med., and raw sienna

Step Three Next I build up the background with a thin, diluted glaze of ultramarine blue. I darken the shadows on the teacup and saucer with a glaze of cobalt blue mixed with burnt umber. When the color dries, I paint a thin line of cadmium yellow medium along the rim of the teacup and, while still wet, I drop in a touch of raw sienna for the darker sections. Then I glaze over the tulip leaves with a mix of Prussian blue, cadmium yellow medium, and raw sienna. I add the flower stems, using dark green for the shadowed sides; then I use clear water to pick up some of the dark green and pull it over to the light edges of the stems.

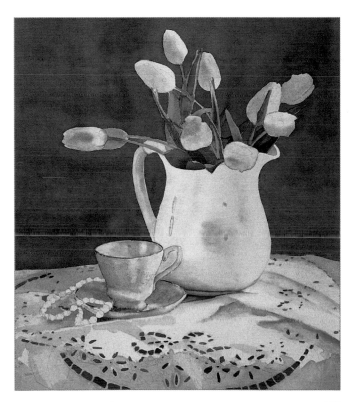

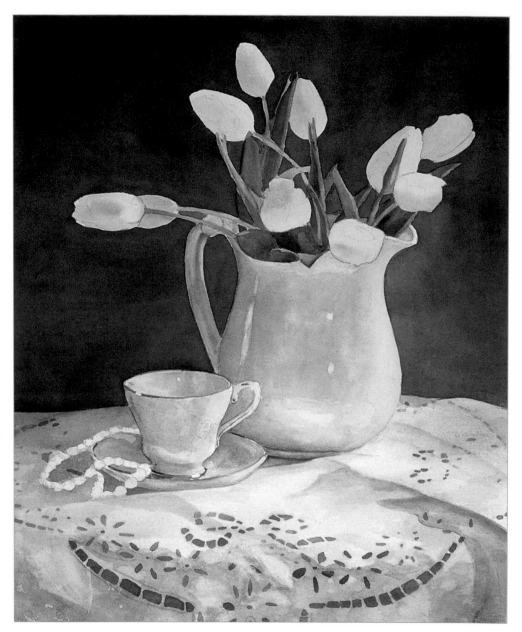

Step Four I apply a glaze of ultramarine blue mixed with burnt umber over the background and use the same mix to darken the shadows on the lace, teacup, and saucer. Then I paint the shadows on the pitcher with a lighter mix of ultramarine blue and a touch of burnt umber. I darken the leaves with a mix of viridian green and burnt umber. Then I remove the frisket from the pitcher and apply a light glaze of cobalt blue over the highlights. I darken some tulip petals with cadmium yellow medium and others with alizarin crimson, occasionally using a diluted cobalt blue for the shadows.

Shadows

Ultramarine blue and burnt umber

Leaves

Viridian green and burnt umber

Tulips

Cadmium yellow medium and alizarin crimson

26

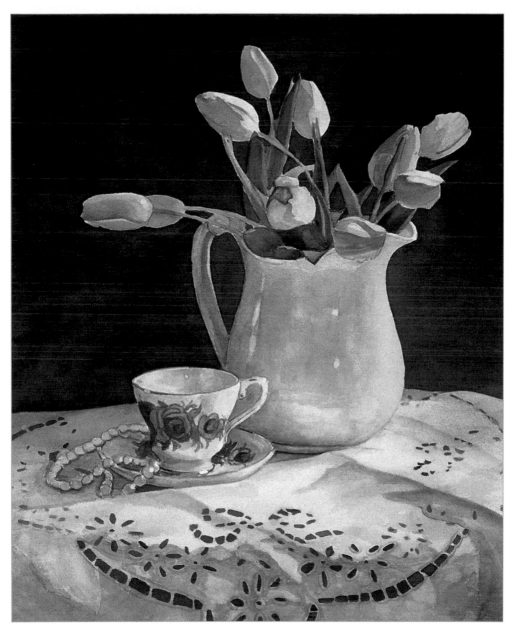

Step Five Now I apply the final background glaze, using a dark mix of ultramarine blue and burnt umber so my center of interest really "pops" out. With a small round brush, I paint the rose motif on the teacup, letting each section dry before painting the next so the colors won't bleed. I use the same small brush to apply a mix of ultramarine blue and burnt sienna to each pearl. Finally, when everything is dry, I darken the shadows on the front and back of the lace with a glaze of ultramarine blue mixed with a touch of burnt sienna; this makes the fabric recede a bit and lets my tulips take center stage.

Background Glaze

Ultramarine blue and burnt umber

Pearls and Lace Shadows

Ultramarine blue and burnt sienna

Creating Animal Portraits
with Marilyn Grame

Animals are fascinating subjects to paint because there is such a wide variety of subjects to choose from, and all have their own distinctive coloring, textures, and features. But few things are more appealing than painting the likeness of an animal friend you know and love. With this portrait of a dog named Flyer, animal specialist Marilyn Grame shows how animal portraiture goes beyond duplicating the physical characteristics and actually captures the personality of the individual subject.

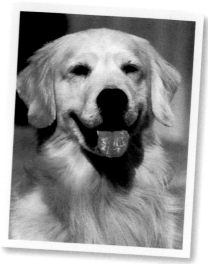

Painting an Active Subject Dogs are one of my favorite subjects to paint, but convincing a golden retriever like Flyer to sit still and model for an entire painting session would have been impossible. Instead I worked from a photograph. If you take your own photos, I recommend that you experiment first with different poses and film speeds until you find a shot you're pleased with and that shows the animal's personality. Then use the photo as a reference to create a realistic portrait of your furry friend.

Color Palette
burnt sienna, burnt umber, Payne's gray, alizarin crimson, raw sienna, ultramarine blue, white gouache, yellow ochre

Step One I begin by drawing a fairly detailed sketch, indicating the areas where the colors and values change and the direction in which the fur grows. I pay careful attention to the features that make Flyer unique from other golden retrievers, such as the light areas of his face, the way his fur curls, and the shape of his eyes. But I also want to make sure I include elements of his personality: the gentle expression and the happy "grin." Then I dampen the background area and use a medium round brush to cover it with an ultramarine blue wash; this will provide a nice complement to the warm, golden color I'll use for his coat. I use the tip of my brush to paint around the edges of the drawing, but you may want to save the white of the paper by using liquid frisket instead. (Let it dry before painting the background, and remove it before going on to step 2.)

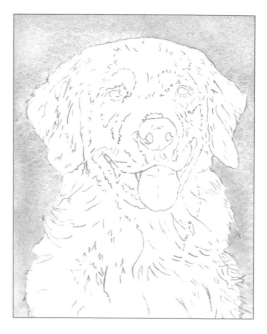

Step Two Now I wash over the entire dog, including the eyes, nose, and tongue, with a light value of yellow ochre. This yellow ochre underpainting—or the initial layer of color—will continue to shine through subsequent layers of color and affect the way each color is perceived. It will be especially important for toning down the pink color of the tongue as the painting develops.

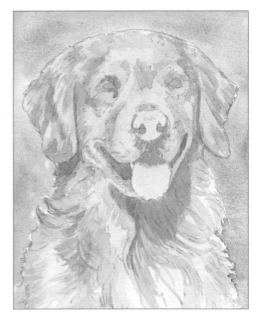

▶ **Step Three** Next I establish shadows and variations in the coat to give the impression of dimension and form. I create a darker value of yellow ochre by increasing the amount of pigment in the wash. Sometimes I blend the darker values where they meet the lighter wash, but other times I leave hard edges to define shadows under the ears and nose, as well as inside the mouth and in the fold of the ears. I build up several coats of the same dark values, letting the paint dry between each application.

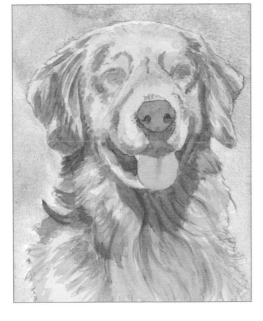

Step Four Now I paint in the red tones of the coat with a medium round brush, using a mixture of raw sienna and a bit of burnt sienna. I pay careful attention to where the dark and light values are in my reference photo, so I am sure to establish a true likeness of Flyer. I also make sure my strokes always follow the direction in which the hair grows. Then I apply a light glaze of alizarin crimson over his tongue and a light neutral-gray glaze of burnt sienna and ultramarine blue over his nose and lips—carefully avoiding the tooth. I also use this gray to tint the upper lip, the muzzle area, and the shadow on the tongue.

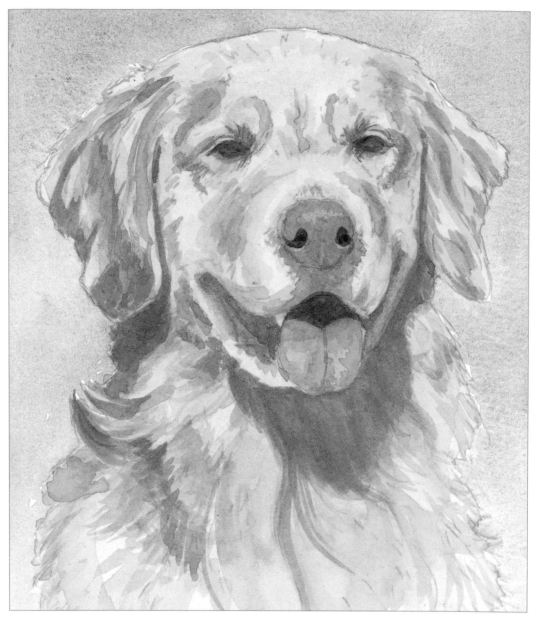

Step Five This is where I begin defining Flyer's unique features. Still using a medium round brush, I add darker shadows to the tongue with a mix of alizarin crimson and Payne's gray. I paint the nose with Payne's gray, working around the highlight areas, and fill in the mouth using a little darker, stronger solution of Payne's gray. Then I switch to the fur around the eyes and, painting light to dark, layer in a mix of raw sienna and burnt sienna. I build up several layers of these values, letting each layer dry before adding the next, and then I repeat the process with a mix of burnt umber and Payne's gray. I add a dark layer of burnt umber to the eyes and use it to glaze under the lid and over the shadows of the fur.

Coat

Raw sienna and
burnt sienna

Tongue

Alizarin crimson and
Payne's gray

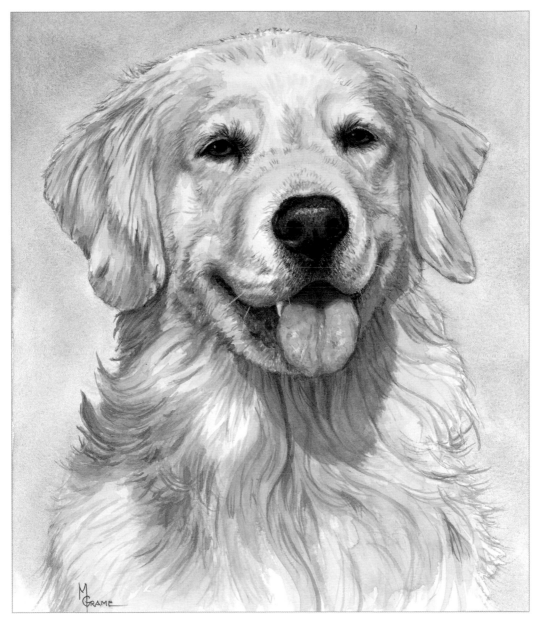

Step Six I pick up burnt umber on a smaller round brush to add more layers to the coat and create details in the shadow areas. Then I mix burnt sienna and burnt umber and apply this warm brown to the left sides of the irises, along with a little burnt sienna in the lower right sides. Once the irises are dry, I blacken the pupils with Payne's gray and then add a highlight using ultramarine blue mixed with white gouache. I pat on several glazes of Payne's gray over the nose and mouth, building up to an almost black color. Then I use my smallest brush and a touch of white gouache for the shine of the nose and the fine whiskers. Finally I tone down the tooth with a light wash of yellow ochre, adding a darker value for the shadow at the top.

Irises

Burnt sienna and burnt umber

Depicting Animal Textures

with Marilyn Grame

Animal hair, fur, and feathers are made up of diverse textures, but you can render them all with a few simple watercolor techniques. Wet-into-wet washes provide a soft, smooth appearance, which makes them ideal for depicting animals at a distance or for duplicating the look of soft down. Multiple layers of drybrush create a rough texture similar to thick fur, while individual strokes with a thin, round brush reproduce the lines of fine hair. In this example of a brightly plumed macaw, Marilyn Grame combines a variety of techniques, including painting wet-into-wet, layering glazes, and adding salt to create interest in the background and provide contrast to the finely rendered feather texture.

Color Palette

burnt sienna, cadmium orange, cadmium yellow light*, cadmium yellow medium, cadmium yellow pale*, cobalt blue, Hooker's green deep*, Payne's gray, phthalo blue, raw sienna, sap green, ultramarine blue, viridian green, white gouache, yellow ochre

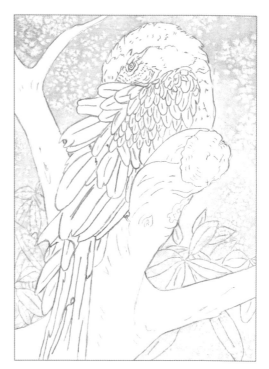

Planning the Painting Because watercolor is a transparent medium, your underlying colors will show through subsequent layers of paint. Therefore, your paintings need to be well thought out before color is applied—an accurate sketch is essential. I draw my subject on tracing paper and then carefully trace over the lines on the back of the paper with pencil. To transfer the drawing to my support, I tape it to the watercolor paper, pencil-side down, and use a coin to rub over the image. I remove any excess graphite from my painting support by patting it gently with a kneaded eraser.

Step One I always begin with the background color, painting up to the edge of the main subject. If I get a little of the background wash on the bird, I will be able to cover it with the stronger colors and glazes I will use on the feathers. I wet the entire background (including the leaves) with clean water; then I apply a graded wash of cobalt blue with a large flat brush. I add more water to each new horizontal stroke as I work downward, so the color lightens as I go. While the surface is still damp (the paint should look shiny), I sprinkle on some salt to create a mottled texture. Then I let the paint dry completely and gently brush away the salt.

Step Two Still using the large flat brush, I begin my under-painting (my first layer of color) by working in a few different values of yellow ochre on the tree. I also glaze a layer of yellow ochre over the lighter leaves. Then I switch to a medium round brush to paint the majority of the macaw, using a slightly smaller brush for the finer details. I use cadmium yellow light to block in the neck, and then I use cadmium yellow medium for the yellow tail feathers and the two accent areas on the body. Next I paint a very diluted sap green on the front of the head.

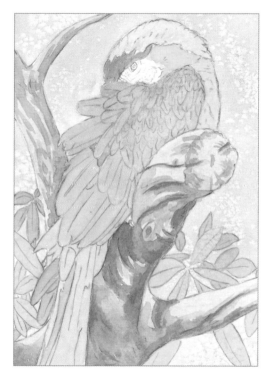

Step Three Now I use a watery cobalt blue for the feathers on top of the head and a diluted mixture of cobalt and phthalo blue for the body and tail feathers. I continue developing the form of the branches with a mixture of burnt sienna and raw sienna, making sure my brushstrokes follow the grain of the wood. I also layer glazes of this mixture to create the darkest values of the shadows. Finally I glaze over the remaining leaves with cadmium yellow pale.

Step Four To add texture to the lighter leaves, I dab on some diluted sap green. I build up the darks under the body and tail feathers with ultramarine blue, and I add a darker value of cobalt blue for a little variation in the feathers on the head. Then I fill in the eye with cadmium yellow light.

Branches

Raw sienna and
burnt sienna

Mixing Gray

Burnt sienna and ultramarine blue

Leaves

Grayed sap green

Hooker's green deep

Viridian green

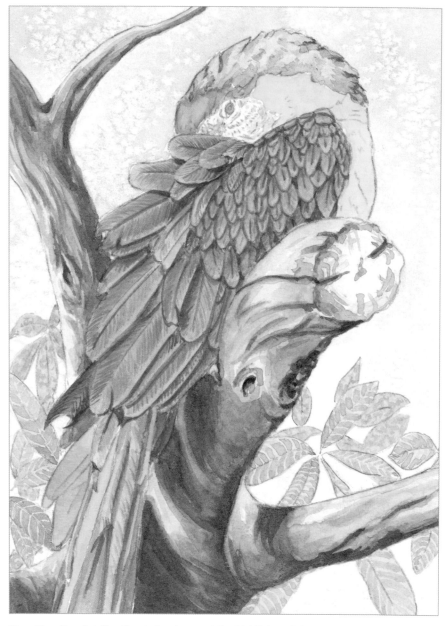

Step Five Now I define the dark values and the highlights of the painting. I begin with the macaw's head, dabbing ultramarine blue among the head feathers and outlining the green area with dark sap green. I define the darker values and details of the branches with a warm mix of burnt sienna and ultramarine blue. For the leaves, I mix a cooler shade of burnt sienna and ultramarine blue and use it to create two values of grayed green—one with sap green, the other with viridian. I work from light to dark, first applying a glaze of the grayed sap green, then a glaze of Hooker's green deep, then a glaze of grayed viridian, leaving lines of the yellow underpainting to indicate the veins of the leaves. To create their rounded shapes, I dampen each leaf's edges, lightening the areas where the light hits most directly. As I paint, I keep in mind that my light source is almost directly overhead, so the highlights should fall on the top of my subject and on the center of my composition.

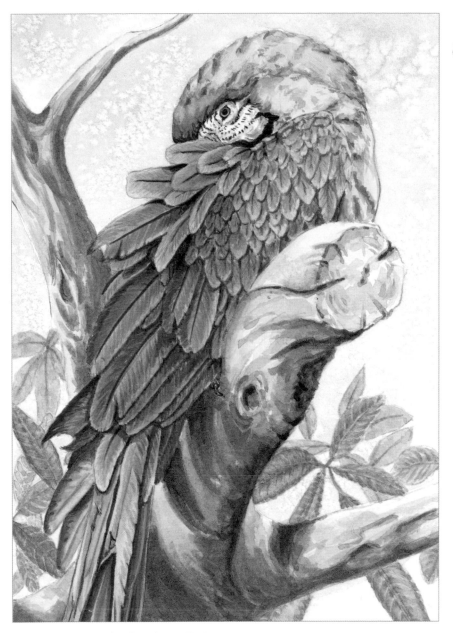

Leaves

Hooker's green
deep and
Payne's gray

Feathers

Cobalt blue and
phthalo blue

Cadmium
yellow medium,
cadmium
orange, and
burnt sienna

Step Six Finally I paint the veins on the lighter leaves with a grayed sap green, and I define the darker leaves with Hooker's green mixed with Payne's gray. Then I use raw sienna to glaze the leaf veins and shadows, and, when dry, glaze the leaves again with ultramarine blue. Next I shape the yellow feathers, beginning with cadmium yellow medium, then mixing in cadmium orange, and finally adding a touch of burnt sienna. I deepen the green feathers on the head with a progression of sap green, Hooker's green deep, and a mix of Hooker's green deep and Payne's gray. Then I mix cobalt blue, ultramarine blue, and phthalo blue for the details on the body, using phthalo blue mixed with ultramarine blue for the darks. For the accents on the body, I mix phthalo blue, ultramarine blue, and Payne's gray. I add detail to the eye and face with a mix of ultramarine blue and burnt sienna. Then I add a white gouache highlight at the top of the eye.

35

Capturing Animals in Action

with Marilyn Grame

Animals in motion are fascinating to watch and even more exciting to render in watercolor. To portray an animal's movement, start by studying photographs, and practice sketching your subject in various poses and from different angles. Once you have a feel for the way the animal moves, try painting from a photo that catches a movement that appeals to you. Here Marilyn Grame describes how she was able to show a favorite colt's beauty and agility by faithfully following her "lucky shot" photograph.

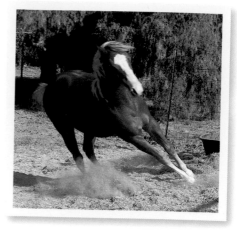

Color Palette

burnt sienna, burnt umber, cadmium red light, cobalt blue, Payne's gray, raw sienna, sap green, yellow ochre

Working with Photographs I couldn't believe my luck when I was able to photograph this colt in the midst of a quick, tight turn. The speed of the colt's movement caused my digital image to blur a bit, but the horse's form and definition are still clear enough to make the photo useful. To add more life and vibrancy to my painting, I substituted a blue sky for the background to complement the colt's golden coat.

Step One I lightly sketch in my composition before I begin painting, being careful to capture the correct angle of the horse's body and the movement of the forelock, mane, and tail. Then I wash clear water over the sky area. The paper absorbs the first coat of water, so I apply a second layer of water to ensure that my paint flows smoothly. Painting wet-into-wet, I apply a wash of cobalt blue using a medium round brush. I stroke in the color at an angle, leaving white spaces to simulate wispy clouds. Notice that I angled the clouds to the right, to counterbalance the thrust of the left-leaning colt.

Step Two After the sky has dried, I block in the landscape. I wet the ground, tree, and mountain areas with clear water, but I merely dampen the edges around the dust cloud so I have more control over the flow of paint. Then I wash a light value of yellow ochre over the landscape, bringing the wash only to the damp outline of the dust cloud so that only a little color spreads along the edges. While the paint is still wet, I use a tissue to lightly blot the edges of the dust cloud to soften any hard edges.

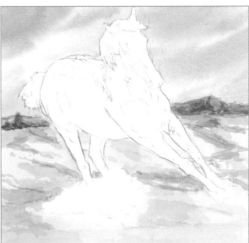

Step Three I start to define the landscape by using a diluted mix of yellow ochre and cadmium red light for the middle values on the mountains. When the first coat is dry, I add burnt sienna and a touch of Payne's gray for the shadows. I build up the ground with a series of fairly light glazes: first yellow ochre and then raw sienna. Next I tone sap green with some Payne's gray and paint the trees and ground cover.

Mountains

Yellow ochre and
cadmium red light

Trees and Ground Cover

Sap green and
Payne's gray

Step Four When the background is dry, I wash yellow ochre over the colt, painting around the white mane, tail, blaze, and stockings. I continue to work on the ground detail, using the same grayed sap green washes and yellow and raw sienna from step three to build up the dark areas in the dry dirt and vegetation.

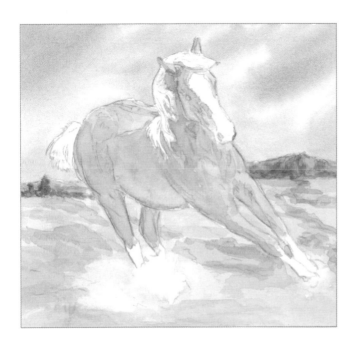

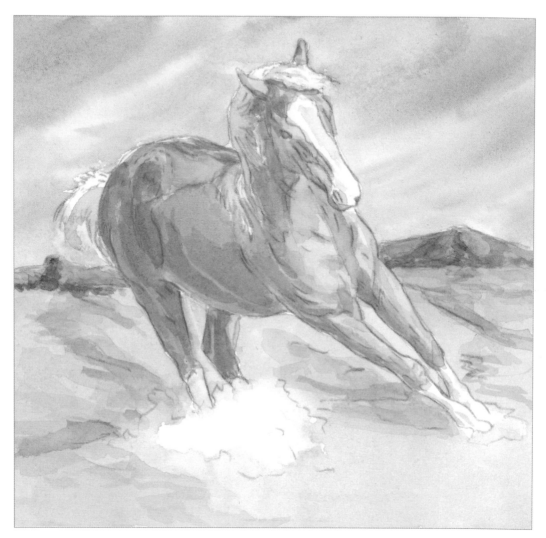

Step Five Although you can't see it in the photo, the sun is shining from the right side of the painting. To define my light source, I highlight the colt from the right side, and I indicate the shadows on the left. I build up the shadows using a second glaze of yellow ochre, this one with more pigment and less water. Next I begin defining the shadows in the white areas, using a light wash of Payne's gray mixed with burnt sienna.

Step Six Now I add my darkest values. I glaze yellow ochre, raw sienna, and then burnt umber over the colt, letting each glaze dry before applying the next. Then I define the shadows in the whites and darken the cast shadows with a mix of Payne's gray and burnt sienna. I also continue refining the vegetation with the grayed sap green mix. I lightly wash over the dust cloud with the Payne's gray and burnt sienna mix and pat the damp area with a tissue. Finally I add highlights at the ends of the mane and tail by scraping off paint with a utility knife.

Focusing on Reflections

with Geri Medway

Water is an appealing subject because it can take so many different forms, from a peaceful lake to a violent, surging sea. And watercolor is a fluid medium that lends itself well to the subject of water and reflections. Keep in mind that the way water reflects its surroundings depends on whether the water is moving or is at rest. In moving water, reflections distort the size and shape of the objects being reflected, whereas in still water the reflections mirror the objects almost exactly. In this scene, Geri Medway illustrates how to paint the gentle movement of the harbor water and the slightly rippled reflections of the boats at dock.

Color Palette

cadmium red deep*, Indian yellow*, indigo blue*, peacock blue*, phthalo blue, ultramarine blue, white gouache

Water

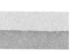

Phthalo blue
(light and dark glazes)

Phthalo blue and a touch
of ultramarine blue glaze

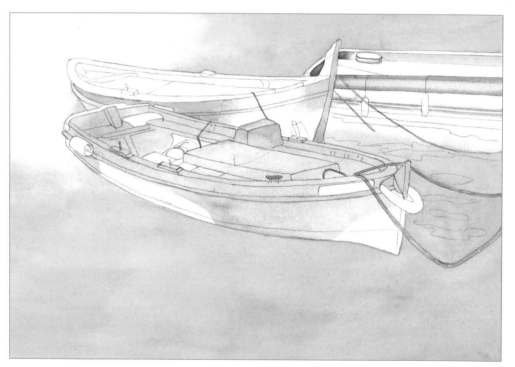

Step One Once my sketch is complete, I mask off the ropes with colored liquid frisket (see Masking Whites on page 42). When the frisket is dry, I start applying background washes with a large round brush. (I use one large round brush with a fine point throughout, and I use a separate brush for the clear water of my graded washes.) I begin by applying a thin ultramarine blue wash over the boats. When this is dry, I glaze a second, darker layer over the shadowed areas. Then I wash phthalo blue over the water area, taking care not to make the color too even. The slight inconsistencies in color will help create the illusion of movement in the water.

40

Painting from Life

Photos are wonderful reference tools and are invaluable for many projects, such as depicting animals in motion or capturing a fleeting sunset. But nothing compares to actually being on location and experiencing your subject firsthand. Watercolor is an easily portable medium—most drawing boards have handles, the paints are available in transportable pans and small tubes, and the only additive you need is water. But you can learn just as much from detailed notes and drawings you make in a sketchbook. Take a small sketchbook wherever you go, and draw whatever attracts your eye. Make notes about colors, lighting, and mood so you can re-create it later in your studio.

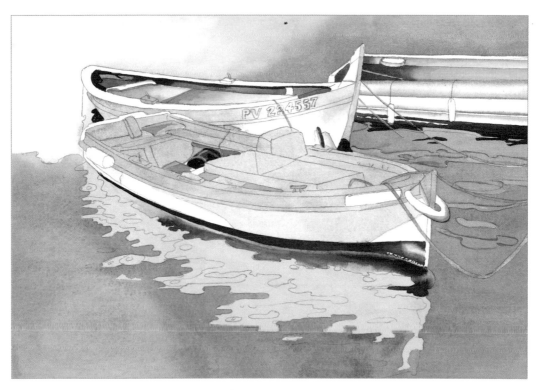

Step Two Now I start adding the colors, beginning with a thin glaze of burnt sienna for the brown areas. After the first layer has dried, I apply a second coat with a little more pigment and then repeat the process, building up successively darker layers. Then I add a flat wash of cadmium red deep to fill in the bottom edges around the boats, the buoys, and the reflections in the water. For the lighter values, I gradually add more water to each successive stroke. There is not much movement in the water, so the reflections are only slightly rippled. Next I lay in a second glaze of phthalo blue over the water, painting around the reflections. When dry, I add a little more depth with a third glaze using phthalo and a little ultramarine blue.

41

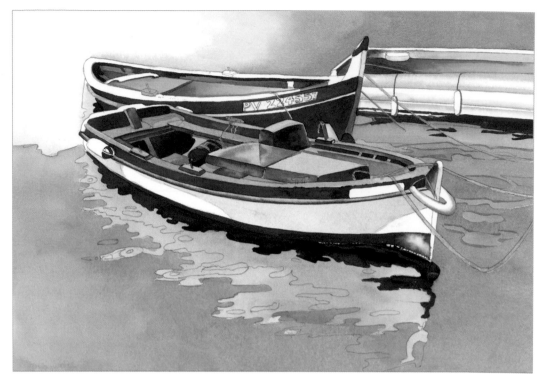

Step Three For the boat interiors, I begin with a thin layer of ultramarine blue. I let it dry and then apply a darker blue mix of indigo blue and ultramarine blue. (I use enough of the indigo blue to achieve a good, dark color but not so much that it overpowers the richness of the ultramarine blue.) Next I add touches of sunshine with a few strokes of Indian yellow along some of the inside edges of the boats.

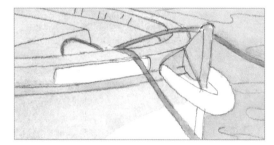

Masking Whites Detail To mask off the ropes and other small white areas, I apply liquid frisket with a crow quill pen. The short, pointed nib of the pen allows me to work with careful precision inside tight spaces and to achieve small, uniform lines.

Boat Interior	Water Glaze
Indigo and ultramarine	Peacock blue

Creating Ripples Detail
To indicate the movement in the water, I brush clear water onto my surface. I don't wet it too thoroughly, as I want to maintain some control over how far my color spreads. Next I apply zigzagging strokes of peacock blue, letting the color bleed a little.

Finishing Detail
When the painting is thoroughly dry, I gently rub away the frisket, revealing the white of the paper. Then I paint in the shadows and details with the pointed tip of a medium round brush and ultramarine blue. This example shows the progression from applying frisket to adding details.

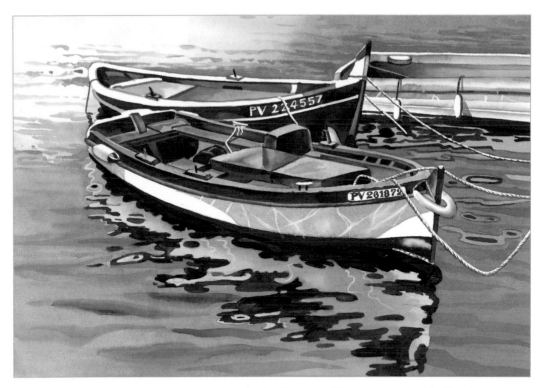

Step Four After adding ripples to the water (see the detail on page 42), I glaze over it with diluted peacock blue and let it dry. Then I add a glaze of peacock blue mixed with a touch of phthalo blue and let that dry. Then I apply one more layer of peacock blue. I build up these thin layers of paint because the color has greater intensity (saturation) than it would if I applied only one thick layer of pigment. When dry, I add the details and let the painting dry before removing the frisket. Then I add final details to the ropes (see the detail on page 42), the reflections, and the boats (see below).

Using Gouache

Rather than saving the white of my paper to create the reflected light on the boat, I use white gouache and a medium round brush. Gouache paints are water-based, but they are more opaque than regular watercolors. They can be mixed with watercolor to thicken it or they can be applied directly, as in this example. I chose to use gouache because it gives the whites a more vibrant look than the textured paper alone would, and it allows me to blur and soften the edges of the highlights and shadows to show movement in the water.

Portraying Dramatic Flowers

with Geri Medway

Flowers are a favorite subject of many watercolorists, and they are often rendered in bouquets or included as elements in a still life or landscape. Their vibrant colors and diverse shapes always add interest to a composition, but there's no need to restrict yourself to painting flowers in groups. By focusing on a single flower or pair of flowers, you can create a delicate floral "portrait" or make a dramatic visual statement, as Geri Medway does with this closeup view of a bird of paradise in bloom. Layers of glazes produce deep, rich tones, and the contrast of bright colors against the dark background help make this exotic tropical flower leap off the paper and seem real enough to touch and smell!

Color Palette

cadmium orange, cad. red deep*, cad. yellow light*, cad. yellow medium, peacock blue*, permanent alizarin crimson, permanent rose, phthalo blue, phthalo green*, sap green, ultramarine blue, vermilion*

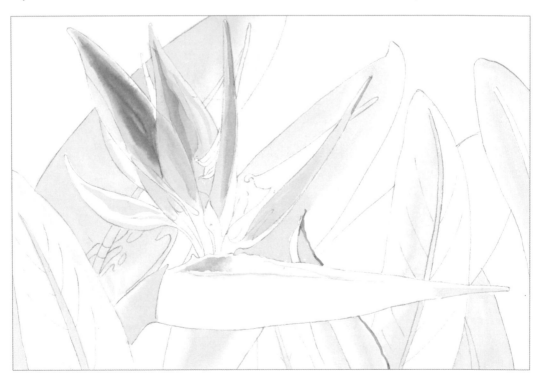

Step One After sketching in the shapes, I lay in my initial washes with a large round brush. I start with a thin cadmium yellow light wash for the outer edges of the leaves and some of the central veins. Then I deepen the area with a higher concentration of color for the background leaves and what I refer to as the "neck," "beak" outline, and "feathers" of the flower. When the first washes have dried, I add cadmium orange to darken the "eye" and the "feathers" of the flower.

Lifting out Color

Though watercolorists usually "save" the white of the paper when they want pure white, it's also possible to "lift out" color to lighten the tone. With this technique, you absorb some of the moisture—and thus the color—of the paint you've applied to the paper. While your wash is still damp, use a paper towel, tissue, paintbrush, or dry sponge to dab at or sweep across the wet paint to lift it off. If your paint has already dried, moisten the area you want to lighten with clear water, and then lift the color off with the tissue, brush, or sponge.

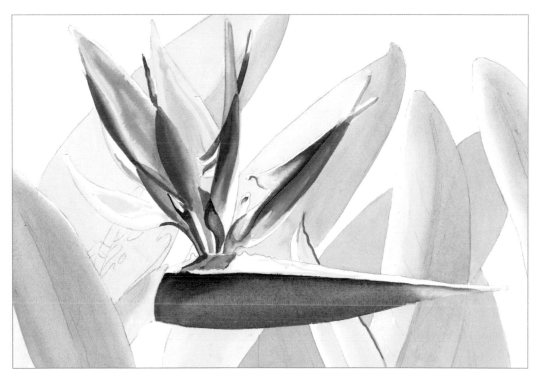

Step Two To create the form of the leaves, I wash bright vermilion on the foreground leaves, using both flat and graded washes. Next I lay in a graded wash of permanent rose along the flower's "beak" and on the lower "feathers." When dry, I add a graded wash of ultramarine blue on the beak and some of the "feathers." Then I finish the "feathers" with glazes of cadmium red. Finally I glaze peacock blue to cool some areas of the leaves, allowing the color to blend here and there with the yellow underpainting.

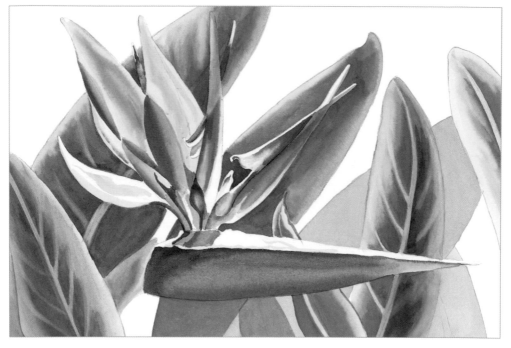

Step Three Now I glaze the green leaves with a mixture of sap green and phthalo blue. I use just enough blue to take away some of the brightness of the green. However I continually vary the proportions of each color in the mix to create cooler and warmer areas within the painting. After the first layer has dried, I apply a second glaze to deepen the green values. I lift out color to create the veins and lightly soften the edges of the leaves with a damp brush (see the details below).

Veins Detail While the paint on the leaves is still wet (see step 3), I lift out color from the veins. I dip a clean brush in water, blot it on a paper towel, and then stroke over the vein area, blotting the paper with a tissue after each stroke. I add a second layer of paint and then soften the edges of the leaf's right side with a peacock blue glaze.

Edges Detail The edges of the leaves initially look too crisp to be natural, so it's important to soften the edges. I dip a brush in clean water, stroke it over a paper towel, and then pull the brush along the dark edge of the leaf. I rinse the brush and repeat the procedure until the edges become soft and blurred.

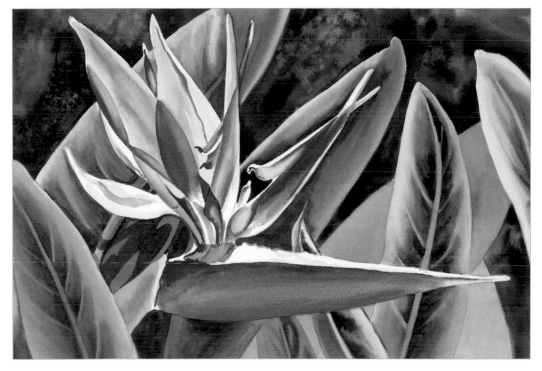

Step Four To finish, I wash peacock blue over the cool side of the leaves before I glaze another layer of the sap green and phthalo blue mix over the leaves. I glaze the warm areas with cadmium yellow medium and the cool areas with peacock blue. Then I add cadmium red deep along the flower's "neck" and on the "feathers." I wet the ultramarine blue area of the "beak" and touch in a little sap green. Then I push back the background leaves by softening the edges. Finally I paint in the dark background (see the detail below) to make the flower "pop" forward and to add drama to the entire painting.

Background	Leaves
Sap green, phthalo blue, alizarin crimson, and phthalo green	Sap green and phthalo blue

Background Detail I paint the background with a dark mix of sap green, phthalo blue, alizarin crimson, and phthalo green. While the paint is damp, I spray clear water over it and then simply watch the color move. The water pushes away the pigment, shifting the color to create a unique, dynamic design.

Rendering Grapes

with Geri Medway

Grapes have long been a popular subject for artists. Each is an almost perfect oval, they grow in interesting clusters of overlapping fruit, and they have a transparent, luminous quality that is easily rendered in watercolor. Thus they provide artists a chance to perfect their skills in developing form, depicting depth and dimension, manipulating color, and creating luminosity. And in an outdoor setting, the effects of natural light and shadow become important elements, just as they do in a landscape. Here Geri Medway masterfully instructs how to render this popular painting subject in a sunlit setting with her own combination of watercolor techniques and personal painting tips.

Color Palette

burnt sienna, cadmium yellow light*, cerulean blue, indigo blue*, permanent alizarin crimson, permanent rose, phthalo blue, sap green, ultramarine blue

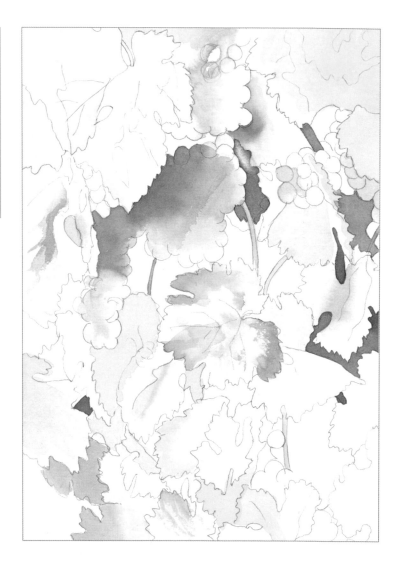

Step One I sketch in the masses of grapes and the shapes of the leaves. Then I use a large round brush to lay in my initial washes. I use permanent rose for the grapes, and I use both cadmium yellow light and a mix of cadmium yellow light and permanent rose for the leaves. I add a few flat washes for the areas in shadow but otherwise use graded washes to create variations of lights and darks. These changes help establish an "underglow" on the leaves and grapes.

Speeding Up the Drying Process

Using a Hair Dryer You can hasten the drying time between paint layers by using a hand-held hair dryer. Hold the dryer at least 8–10 inches away from the painting surface, and always use the lowest heat setting.

Problems to Avoid Never hold the dryer this close to the surface. Before using a hair dryer, let the wash dry slightly. Blow-drying too soon can produce unwanted runs and ripples.

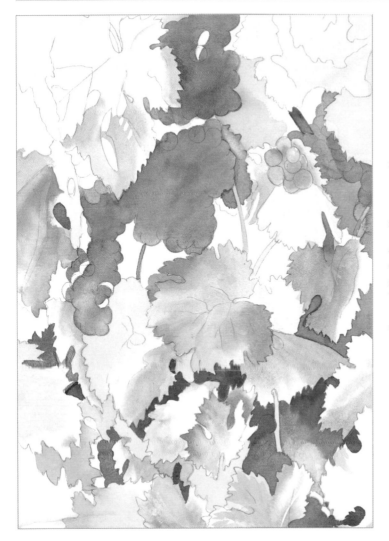

Step Two Next I paint ultramarine blue over the masses of grapes, letting the permanent rose underpainting show through in places. Then I add both flat and graded washes of cerulean blue to the leaves, saving some white spaces for sunlit highlights. When painting the highlights, I keep in mind that the light source is coming from the upper left of my composition.

Step Three Now I'm ready to start working in my darks, beginning with the deep greens. To paint the leaves, I use sap green mixed with phthalo blue and a little burnt sienna (see the detail below). I also start to paint in the dark background, layering glazes of sap green mixed with phthalo blue, letting each layer dry before painting the next.

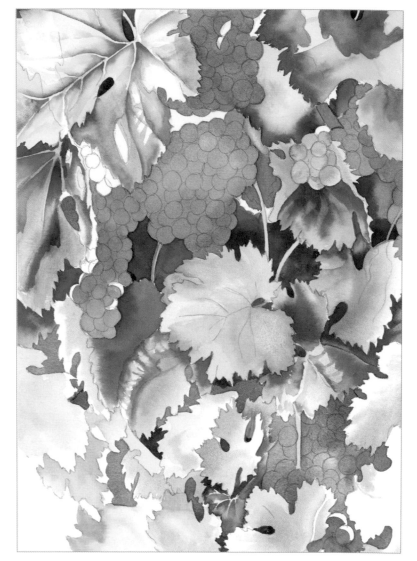

Leaves

Sap green, phthalo blue, and a little burnt sienna

Sap green and phthalo blue

Leaves Detail I apply a very light, graded wash of sap green, a little phthalo blue (only enough to take the brightness away from the sap green), and a touch of burnt sienna over the leaves. Then I add a stronger solution of this same mixture over the areas near the veins that I want to be a little darker. In this way, I'm creating the veins by painting the areas around them— but the technique produces a look similar to a graded wash. Then I lift off the color from the veins with a clean, damp brush. To create the shadows on the leaves, I wait for the color to dry and then glaze over each area with cerulean blue.

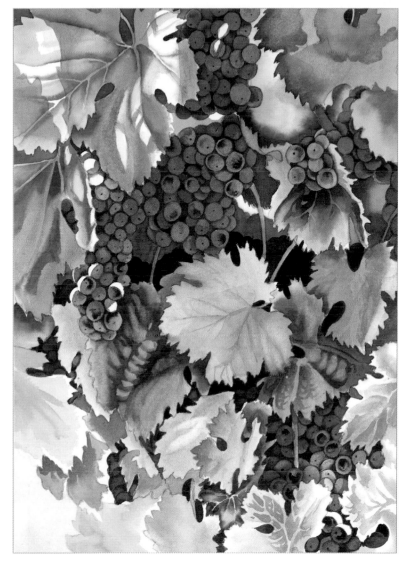

Step Four Now I glaze over areas that need to recede with sap green and phthalo blue (slightly favoring the blue). Then I define the forms of the grapes and paint their "dimples" using a mix of alizarin crimson and ultramarine blue. I further define the grapes by outlining each one with a mix of ultramarine blue, indigo blue, and a touch of alizarin crimson. Then I soften the darkest shadows (see glazing detail below). Finally I add glazes of the same sap green and phthalo blue mix used in step three.

Grapes

Ultramarine blue and a glaze of alizarin crimson and ultramarine blue

Ultramarine blue, indigo blue, and a touch of alizarin crimson

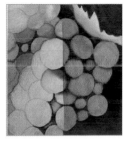

◀ **Glazing Detail** I deepen the values of some of the grapes with an additional glaze of alizarin crimson and ultramarine blue. The glaze is like a light veil of color that still allows all the other colors to show through. In the example at right, the left side shows the grapes before the glaze, and the right side shows the effect after the glaze is applied.

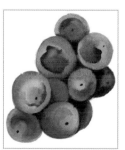

▶ **Finishing Detail** After I outline each grape, I use clear water to soften the edges. The variations in value make the grapes appear three-dimensional and realistic. I also define the shape by adding shadows with a mix of alizarin crimson and ultramarine blue. For a three-dimensional quality, I apply multiple glazes on areas I want to recede.

51

Mastering Landscapes

with Barbara Fudurich

The key to painting successful landscapes is creating the illusion of depth on a flat surface. To do so, you need to establish a foreground, a middle ground, and a background and make clear distinctions among them. For example, because you view distant objects in a scene through the haze of particles in the atmosphere, those objects appear less distinct and more muted in color than objects in the middle ground or foreground do. In contrast, elements in the foreground, such as the flowers in this painting, are closest to you, so they appear more detailed and have brighter colors. In this simple seaside landscape, artist Barbara Fudurich follows these "rules" of landscape composition and guides you through the process of painting a scene with depth and dimension.

Color Palette

burnt sienna, cadmium red deep*, cerulean blue, cobalt blue, cobalt violet, permanent rose, raw sienna, raw umber*, sap green, ultramarine blue, viridian green

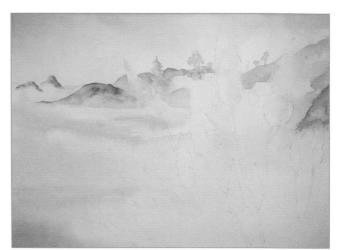

Hills

Cobalt blue and raw sienna

Water

Cobalt violet and cerulean blue

Rocks in Water

Burnt sienna and ultramarine blue

Rocks and Beach

Raw sienna and permanent rose

Step One After sketching in the elements, I wet the entire paper with clear water. Working wet-into-wet with a large flat brush, I wash in varying values of cobalt blue in the sky and lift out the clouds by dabbing the wet paint with a tissue. I wash cobalt blue in the ocean as well, but I mix in spots of cerulean blue and add hints of raw umber. For the distant hills, I apply an initial wash of raw sienna. When this dries, I add rocks to the middle ground (see the detail below). I glaze a muted cobalt blue mixed with raw sienna over the hills, allowing the colors to blend on the paper. I add another glaze of cobalt blue and raw sienna over the same areas, using a darker value in the foreground to bring it forward. I pull up color with the tip of my brush to merely suggest the distant trees and rooflines.

Rock Detail I hold a large round brush almost parallel to my paper to paint the rocks with a mix of burnt sienna and ultramarine blue. I use the tip of my brush to form the outline of the rocks and use the thick center of the brush to paint the rough edges.

Step Two I dip the tip of my brush in cobalt violet to stroke faint shadows under the distant gazebo. Then I use raw sienna and permanent rose for the beach, brushing over the area where sand meets water with clear water. To create movement in the water, I begin at the horizon with a medium round brush, using ultramarine blue mixed with a bit of cerulean blue. I keep my brush flat at the distant shoreline, skipping it across to suggest broken waves. I also charge in touches of burnt sienna and cobalt violet. Near the shoreline, I add a hint of viridian green to indicate shallow water and to contrast with the darker blue values I used for the deep water.

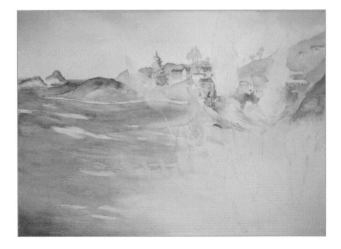

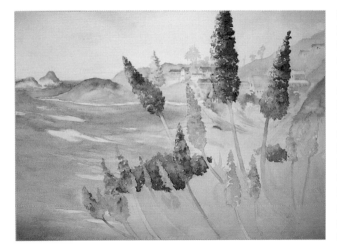

Step Three I add the lighter-colored flowers in the foreground with a bright mixture of permanent rose, cobalt violet, and cobalt blue. I let the colors blend on the paper, leaving little white gaps in each cone shape to indicate individual petals; these foreground flowers will have the most detail and the brightest colors of any element in the landscape (see the details on pages 54–55). For the foliage on the lower right, I apply a wash of sap green mixed with cobalt blue and a hint of cadmium red deep. I also work in touches of both cobalt violet and permanent rose along the hillside to represent distant flowers.

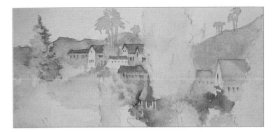

Roofline	Flowers	Foliage
Raw sienna and cadmium red deep	Permanent rose, cobalt violet, and cobalt blue	Sap green, cobalt blue, and cadmium red deep

Houses Detail For the colorful rooflines, I use leftover muted colors from my palette. I apply a light mix of raw sienna and cadmium red deep on some a dark mix of cobalt blue and raw sienna on others, and pure raw umber on others. I wash over the shadowed sides of the buildings in the middle ground with cobalt violet, but I leave white on the sunlit sides. I use the tip of my brush and raw umber to dot in windows, but I don't add as much detail to the buildings as I do to the foreground flowers. I also keep the elements in the distant background free of detail or definition.

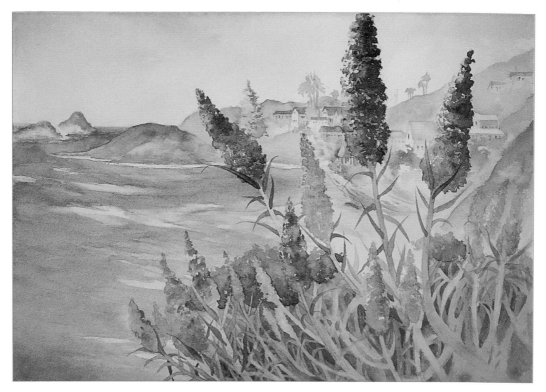

Step Four I paint the stems and leaves in the foreground with a mix of sap green, cobalt blue, and a touch of cadmium red. I press down on my brush at the stem and then lift up as I pull the brush away to taper the ends of the leaves. To define the shapes of the lighter leaves, I paint the dark negative spaces around the leaves instead of painting the leaves themselves. I occasionally add burnt sienna for variation.

Painting the Flowers

Step One With a medium round brush, I wash cobalt blue over the lightest areas of the three largest flowers, pressing the thick part of the brush against the paper to create the appearance of clusters of flowers. I add touches of cobalt violet to create variation and add viridian green to the mix as I near the base of the flowers, pulling the color down to make stems.

Step Two There should be a lot of color variation in these flowers; they are quite blue at the tips, but they appear greener near the base where the blossoms haven't yet opened. While the paint is still wet, I add darker values to create shading and volume, using a mix of ultramarine blue and cobalt violet. I also add some sap green to create a darker area near the base of the flowers.

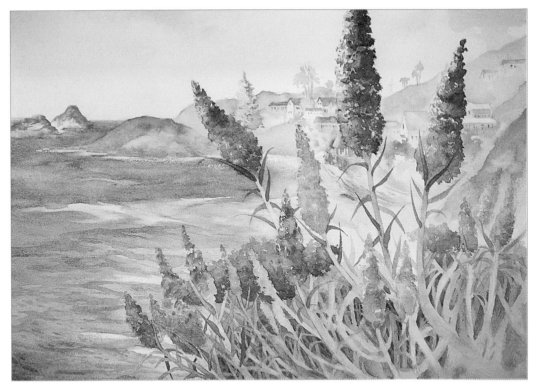

Step Five To complete the water, I paint some additional ripples. I start at the top with viridian green, work downward with cobalt violet, add some burnt sienna, and end with cobalt violet mixed with cerulean blue. Then I lay in the final details, adding another layer of the cobalt blue and cerulean blue mix in the white areas between the point of land and the distant shore. Finally, using a brush and clear water, I lift out a bit more of the surf around the point of land.

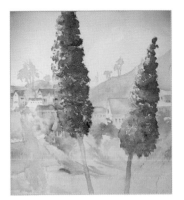

Step Three I return to the three largest flowers while the paint is still damp, creating a shadow on their right sides by charging in ultramarine blue, cobalt violet, and sap green. I continue to paint the rest of the flowers in the same manner that I painted the larger ones, but I leave out the details and subdue the colors to keep these flowers slightly out of focus—pushing them clearly behind the others.

Lifting Out with a Flat Brush To lighten the stem of the flower that stretches across the ocean, I wet a flat brush with clear water and lightly rub the bristles against the stem to loosen the pigment on the paper. Then I press a tissue against the wet paint to lift out the extra pigment, leaving behind a lighter value of the color.

Simplifying a Subject

with Barbara Fudurich

Sometimes a scene is so compelling that you want to paint it all, but you can't possibly fit everything on your watercolor paper. That's why you need to simplify the scene. Decide what element is the most striking or the most representative of your subject, and concentrate on that—don't try to paint every stone, leaf, and petal. Here Barbara Fudurich shows how to take the complex architecture and gardens of a mission scene and focus on the beauty of a simple row of arches framed by the mission's signature bougainvillea.

▶ **Sketching the Scene** The mission and its grounds were vast and beautiful, so I narrowed my focus to one area that exemplified the best qualities of the building and its surroundings. Once I decide on this intimate view of the garden through a row of arches, I sketch it lightly on my watercolor paper. Remember: Use your sketch as a guideline only; you don't need to draw in every detail. A general outline of the shapes of objects and shadows is all you really need.

Color Palette

aureolin yellow*, burnt sienna, cadmium orange, cadmium yellow medium, cobalt blue, cobalt violet, permanent alizarin crimson, permanent rose, raw sienna, sap green, ultramarine blue, viridian green

Initial Washes

Cadmium yellow medium, alizarin crimson, and cadmium orange

Cadmium yellow medium, alizarin crimson, cadmium orange, and permanent rose

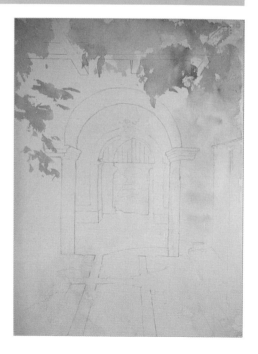

Step One Using a large round brush, I cover the entire paper with a very diluted wash of cadmium yellow medium mixed with alizarin crimson and a touch of cadmium orange. Every time I reload my brush, I alter the wash slightly by adding new colors, constantly changing the makeup depending on what area I'm covering. For example, I vary the wash on the right side of the archway by adding more cadmium yellow medium and cadmium orange for shadows. And as I move into the blossom area, I add permanent rose. Then I use the side of the brush to block in permanent rose for the blossoms.

56

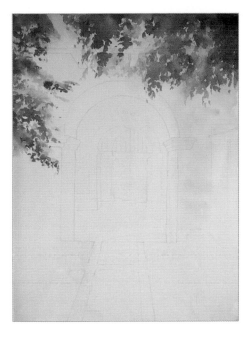

Step Two By squinting my eyes, I can reduce all the leaves to masses of different values, which helps me simplify the subject. Still working wet-into-wet, I stroke in a wash of aureolin yellow and a bit of viridian green for the foliage. First I apply the paint with the side of my brush to create jagged areas of light green foliage; then I mix in a little cobalt blue for the darker, shaded areas. Next I add some burnt sienna to the mix for the dark green area in the upper-right corner.

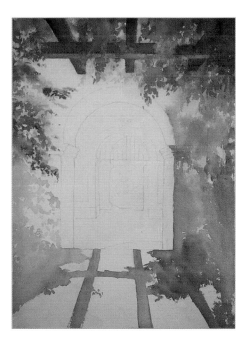

▶ **Step Three** I apply another glaze of the cadmium yellow medium, cadmium orange, and permanent rose mix below the foliage, adding touches of cobalt blue and ultramarine blue for shadows. Then I add trellis beams with alizarin crimson and sap green, lifting out highlights. I paint the shadows with cobalt blue, burnt sienna, permanent rose, and cadmium orange.

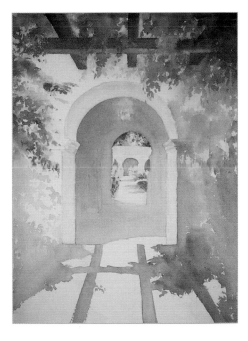

Step Four Next I paint the inner courtyard garden with aureolin yellow mixed with viridian green, adding cobalt blue for darker foliage and ultramarine blue for shadows and keeping the forms slightly blurred in the background. The background archways are a mix of cadmium yellow, permanent rose, and cadmium orange, with cobalt violet for upper-arch and sidewalk shadows. I start the center arches with cadmium yellow on the chandelier; then I wash over the archway with a mix of cadmium yellow, permanent rose, and cadmium orange. I keep the curve of the foreground arch the lightest and add glazes for each darker, receding arch. I paint the area around the front of the arch with raw sienna mixed with permanent rose, and I add cadmium orange highlights to the top of the arch and the side pillars. I fill in the area between the arches with raw sienna, permanent rose, and burnt sienna.

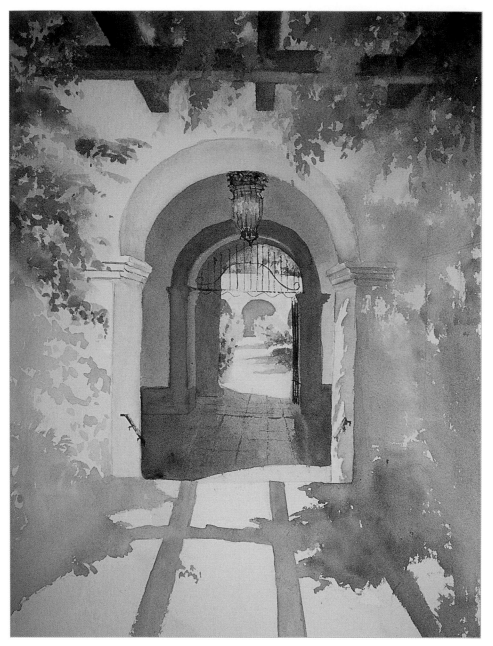

Step Five To create the brickwork around the inner arches and floor, I add a final layer of burnt sienna, alizarin crimson, and a bit of cobalt blue, cooling the mixture with more blue for the floor. I add even more cobalt blue for the highlights on the tile floor, lightly lifting some of the pigment with a tissue. When the area is dry, I add the grouting with a dry rigger brush and a darker value of the tile mix. Then, while constantly varying the thickness, darkness, and dampness of my lines, I create the ironwork with the rigger brush, using burnt sienna mixed with ultramarine blue. I define the tops of the pillars using a mix of cobalt blue, burnt sienna, permanent rose, and cadmium orange; then I take a clean, damp brush and soften the edges of the shadow where it creeps up the wall. I also use this mixture on the right side of the archway, favoring a warmer shade as I near the bottom.

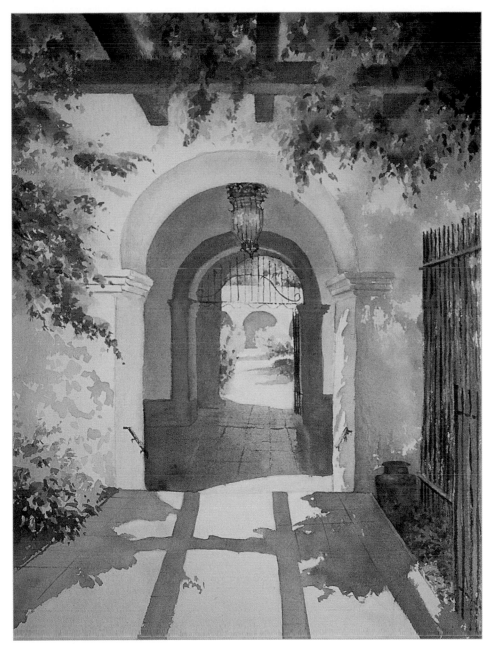

Step Six I add the foreground foliage using a mix of aureolin yellow and cobalt blue. I paint the ironwork and drybrush the fence with burnt sienna and ultramarine blue. Next I add ultramarine blue to the mix of aureolin yellow and cobalt blue and blend this color from the base of the bush at left into the ground. I add the same mix to the bougainvillea, along the bottom of the fence, and along the edges of the green foliage. I mix burnt sienna with ultramarine blue for the flowerpot, using darker values for the shadows. Then I mix cobalt blue, burnt sienna, permanent rose, and cadmium orange and define the walkway edge with the tip of a dry brush. I dot light and dark values of alizarin crimson into the foliage for flowers. With the rigger and a mix of ultramarine blue and burnt sienna, I add texture lines to the fence. Then, with more burnt sienna in the mix, I add the final shadows on the tiles.

Painting Outdoor Still Lifes

with Barbara Fudurich

Still lifes don't have to be objects in interior settings with artificial light and contrived arrangements. You can also "find" a wonderful still life composition in your garden, around your neighborhood, or in any outdoor setting. What is the difference between a landscape and an outdoor still life? A *landscape* is generally a scene in nature untouched by human hands, whether a vast panorama or an intimate closeup. However an *outdoor still life* is an arrangement of objects—natural, human-made, or both—that someone has deliberately composed (though not necessarily intended as the subject of a painting). A fountain surrounded by potted plants, a collection of seashells on a porch, or bird bath placed in a verdant garden are all examples of outdoor still lifes. Artist Barbara Fudurich has always been drawn to the beauty and simplicity of outdoor still lifes, and this simple watercolor of a sidewalk café demonstrates her passion and ability for finding charm and allure in a seemingly ordinary setting.

Color Palette

aureolin yellow*, burnt sienna, cerulean blue, cobalt blue, permanent rose, raw sienna, ultramarine blue, vermilion*, viridian green

Step One After completing my sketch, I use a large flat brush for an overall wash of raw sienna mixed with a touch of permanent rose. Working from left to right, I continue adding more raw sienna so that the wash has a pinker tone on the left. I save the white of the paper for the flowers on the bottom right and for the curtains by painting around them. When the wash has just lost its shine, I spatter on clear water with a toothbrush to create the look of stucco.

Step Two I complete the rest of the painting using mostly a medium round brush with a fine point. First I lay in a light wash of cobalt blue mixed with a touch of cerulean blue over the umbrellas. When dry, I apply a wash of pure cobalt blue, beginning underneath the umbrellas and continuing down the shutters. Then I soften the bottom edges with a damp brush so that the shutters will gradually blend into the foliage.

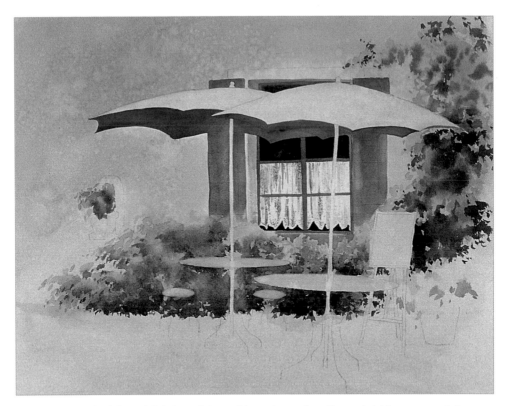

Step Three For the foliage, I lightly wash in a mixture of aureolin yellow and viridian green, painting irregular edges so they appear more natural. I add cobalt blue to the wash for the darker areas, but instead of adding it to the mix, I drop it into the painted wash for a random, more realistic effect. I add even darker values by mixing in ultramarine blue and occasionally some burnt sienna for variety. As I build up glazes, I soften some edges by touching them with a damp brush. I also change the proportions of yellow and blue with each glaze, varying the shades of green so the foliage doesn't appear flat.

Painting the Window

Step One I paint the window frame and the upper windowpanes in one solid, dark wash of burnt sienna mixed with a bit of raw sienna. I paint around the curtains but touch in a little of the dark color in the bottom panes to define the bottom of the curtains.

Step Two When dry, I paint over the panes, including the area below the curtains. I use a dark, rich mixture of equal parts ultramarine blue, vermilion, and burnt sienna. While still damp, I brush in clear water to push the pigment back slightly, suggesting a reflection in the windowpane.

Curtain Detail Since the curtains are white, I define their shape by painting the shadow areas in the folds. I start with uneven, vertical strokes of cobalt blue mixed with vermilion, and I occasionally blot the paint with a tissue to create varied values. Then I dot on the pattern with the tip of my brush.

61

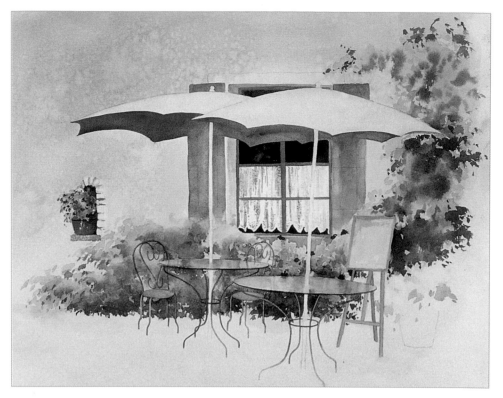

Step Four For the blackboard frame, I mix burnt sienna with a little raw sienna. Then I use the same mix of ultramarine blue, vermilion, and burnt sienna that I used for the windowpanes to paint the recesses of the alcove at the left. To push the foliage back into the shadow of the alcove, I soften the edge with clear water. Then I use the same gray mix to quickly stroke in a ledge under the flowerpot. I paint the pot with burnt sienna mixed with a little permanent rose and darken the mix for the pot's lip. While the pot is still damp, I use the edge of the brush to drop in a purple mix of cobalt blue and vermilion on the right side, letting it bleed into the base to make it appear curved. Then I dab in the red flowers with vermilion.

Painting the Table and Chairs

Step One I lightly wet the tabletops with water and then drop in the colors of the surrounding areas reflected in the glass: the green of the foliage, the blue of the shutters, and the red of the flowers. When dry, I run a dark, thin line of cobalt blue mixed with a little vermilion along the near edge of the tables to add dimension.

Step Two I also wet the seats of the chairs with clear water before dropping in some cobalt blue, letting the pigment spread on its own. I paint the chair and table frames with the cobalt and vermilion mix. Wherever this color doesn't show up against the dark shrubbery, I lift out the pigment with a damp, flat brush.

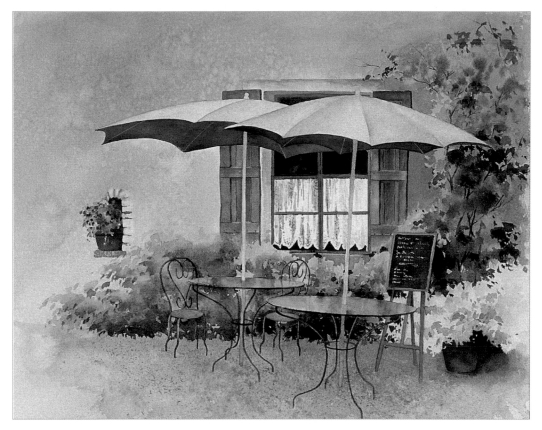

Step Five I mix a gray wash of cobalt blue, vermilion, and raw sienna for the ground, adding more blue on the right side. I spatter on the texture (see the details below) and then drybrush the gray at the top of the window and on the ground behind the tables. I use a lighter gray mix to define the white flowers, and then I wash raw sienna mixed with permanent rose over the right wall. I paint the flowerpot with a darker value of the mix, adding a hint of the purple mix of cobalt blue and vermilion as shown. I drybrush cobalt blue with a touch of purple and the tip of a small round brush to sketch the crossbars and edges of the shutters. Then I shape the umbrellas with glazes of cobalt blue, creating hard edges along the rib lines with the tip of my brush. I use a darker value to separate the umbrellas from the shutters and from each other. With a mix of cobalt blue, permanent rose, and raw sienna, I paint the blackboard. When dry, I squiggle on white gouache with a rigger for the handwriting. Finally I dip a rigger brush alternately into burnt sienna and ultramarine blue and loosely suggest branches in the foliage.

Spattering the Ground

Step One Just when the gray wash over the ground loses its wet, glossy shine, I spatter over it with some clear water using an old toothbrush.

Step Two For my second layer, I darken the cool gray mixture from the ground wash with more blue and spatter that over the base color.

Step Three Without cleaning my brush, I pick up burnt sienna and spatter on this warmer color for a mottled, pebbly look.

Closing Words

Now that you've learned to render a dozen different subjects with a variety of techniques, find some subjects that you'd like to paint, and get started! You never know where you'll find inspiration, so take a sketchbook and camera wherever you go. View the world with an artist's eye to discover the beauty of your local coffee shop, a still life in your neighbor's yard, or a breathtaking landscape on your way to the store. The more you practice, the more you'll learn. So don't be afraid to experiment; soon you'll develop your own unique approach to painting. Above all else, we hope that you enjoy all your watercolor painting adventures!

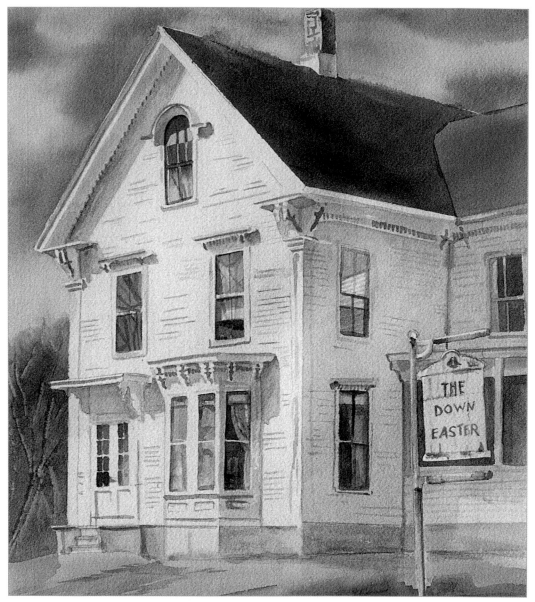

The Downeaster by Lori Simons